1

INTE
RR
U P
TION

Introduction

7 Preface
Nevenka Šivavec

11 The Biennial of Graphic Arts—Serving You Since 1955
Petja Grafenauer

35 Interruption: Shadows in a Volatile World
Deborah Cullen

The 30th Biennial of Graphic Arts Ljubljana: Interruption

50 Allora & Calzadilla
54 Burak Arıkan
58 Dennis Ashbaugh and William Ford Gibson
62 Tammam Azzam
66 Xu Bing
70 Luis Camnitzer
74 caraballo-farman
78 Alex Cerveny
82 Mario Čaušić
86 Vuk Ćosić
90 Milos Djordjevic
94 Tomás Espina
98 Giorgi Gago Gagoshidze and Gianluigi Scarpa
102 Mihael Giba
106 Ana Golici
110 María Elena González
114 Meta Grgurevič and Urša Vidic
118 Dragan Ilic
122 Sanela Jahić
126 Charles Juhász-Alvarado
130 Thomas Kilpper
134 André Komatsu

138 Gorazd Krnc

142 Volodymyr Kuznetsov

146 Nicola López

150 Ivan Marušić Klif

154 Yucef Merhi

158 Ottjörg AC

162 Renata Papišta

166 Adam Pendleton

170 Agnieszka Polska

174 Zoran Poposki

178 Marjetica Potrč

182 Gerhard Richter

186 Venelin Shurelov

190 Teo Spiller

194 Dario Šolman

198 Nika Špan

202 Waltraut Tänzler

206 Rirkrit Tiravanija

210 Vargas-Suarez Universal

214 Tomas Vu-Daniel

The Grand Prize Winner of the 29th Biennial

219 Regina José Galindo: The Anatomy Lesson
 Yasmín Martín Vodopivec

The Honourable Mention Recipient of the 29th Biennial

228 Miklós Erdély: The Original and the Copy + Indigo Drawings
 Annamária Szőke

Appendix

237 Acknowledgements

238 Sponsors

239 Organisation of the 30th Biennial of Graphic Arts

Preface

The 30th Biennial of Graphic Arts is structured as a complex mix of representation and discourse, which is the outcome and sum of the concepts, content, and social networks created by the Biennial's almost 60-year-old tradition. The event is built on the ideas and work of the people who developed it over decades of political, social, and artistic metamorphoses, as well as re-examinations of its institutional position and influence. All of this has shaped its unique history and identity. Today the Biennial of Graphic Arts Ljubljana is seen as one of the print biennials that has most radically expanded the borders of the medium and redefined the concept of the fine art print and printmaking. It has gradually shifted its understanding of the autonomous nature of the print from a strictly technical definition to, primarily, the communicative potential of the graphic medium. The 29th Biennial broadened the thematic focus even further, to include the medium of the art event, which is connected to printmaking primarily through its reproducibility. The 30th Jubilee edition of the Biennial of Graphic Arts returns in its central exhibition to a reconsideration of the nature of graphic processes as it looks at the ways artists of our time respond to the methods and tools of contemporary communication.

The Biennial's 30th edition is both an homage to tradition and an apotheosis of the present. It is composed of the main exhibition, an accompanying presentation of the complex history of one of the world's oldest print biennials, and, as is our tradition, two exhibitions of work by the award-winners from the previous Biennial. There are, as well, a wide range of other accompanying shows and events.

The exhibition on the Biennial's origin and history, *The Biennial of Graphic Arts—Serving You Since 1955*, offers fascinating material that speaks of the event's global dimensions, the evolution of graphic art, and the way the Biennial's format has adapted to new changes and currents in the visual arts. At the same time, it brings a fresh perspective on local history, which has been marked by a unique mesh of politics, business, and culture from the mid-1950s to today. The exhibition represents the first phase in a conscientious and scholarly effort to historicise the Ljubljana Biennial, which up to now has not been subjected to thorough critical analysis and interpretation. As a start, the exhibition weaves

together historical information and documents from official archives; original prints shown at past Biennials, from various art collections; collective and individual memories; and subjective interpretations and artistic interventions that expose the construction of the myth of the Ljubljana Biennial, its preservation, and its gradual transformation into a contemporary art event.

The central exhibition, *Interruption*, conceived and curated by Deborah Cullen, presents artworks from our hi-tech information age, in which economic, geopolitical, and technological conditions are in ceaseless motion, constantly intertwined, and changing faster than ever with the help of the most advanced technologies. With a thorough knowledge of the field, Deborah Cullen has chosen art projects that, while linked by an expanded definition of graphic art, including both traditional and numerous hybrid genres, are also, beneath the surface of the printmaking features they share, grounded in observations, reflections, and interpretations of the interaction between humans and technology. The artists accept technology in two predominant ways: the first is by domesticating and using the machine for a more effective dialogue with nature and society, while the second can be understood as a reaction to the impossibility of controlling the data and tools of the digital information age and, consequently, a return to materiality and originality. The digital age has, clearly, reached the point where the artist feels a need for subjective omnipresence in relation to the material world, which can be understood as compensation for the subject's disorientation in the digital and information wilds. The dystopian atmosphere of determined codependence on the artificial intelligence of machines and a society of surveillance entwines with the aestheticisation of databases and data networks, the mapping of every layer of individual and collective existence, and the creation of universal pictorial languages—all in an endless cycle of destruction and rebirth.

The trigger for the curatorial story of this year's Biennial might well be the mysterious work *Agrippa: A Book of the Dead*, a joint project by the writer William Gibson and the artist David Ashbaugh from 1992. This work, originating at a time when there was a widespread belief that the printed book, and printing in general, would gradually

8

disappear, inscribed in its very beginnings a secret code for its own (simultaneous) destruction and decoding. The book of Ashbaugh's engravings on photosensitive paper was designed so it could be read only one time, while Gibson's poem was encoded on a diskette in such a way that the programme would erase itself irretrievably after a single run. But *Agrippa* found its way into the digital universe and, some 20 years later, is still stirring the imagination and provoking lively debates. The book—said to resemble a mysterious black box that has survived an unknown disaster (at the time of writing, it has not yet arrived in Ljubljana)—is a symptomatic relic of our times and a semantic key that opens a door to understanding the artworks in the exhibition. *Agrippa* contains—metaphorically and literally—the dilemmas of the contemporary archaeology of knowledge and archives, the dilemmas of the analogue and the digital; it contains layers of memory, of the present and the future, challenging us to decipher them, although no hacking skills are needed for this (unless someone wants to try again to break the computer code for Gibson's poem). Browsing through the artists' statements for the works in the show, we find that inspiration for these projects came from both classical iconographic sources as well as popular culture and media, reaching as far as the Tower of Babel, the numerological Tree of Life, and Bosch's *Garden of Earthly Delights*; to films such as Fritz Lang's *Metropolis*, 1927, the horror classic *The Last Man on Earth*, 1964, and Alan Parker's *Angel Heart*, 1987; to cyberpunk and its contemporary variants; to the direct use or appropriation of science, current politics, and the Internet. Thus the exhibition *Interruption* can be read on various levels and offers any number of transitions from the epistemological to the poetic and back again.

The present publication follows the basic structure of the 30th Biennial of Graphic Arts. Petja Grafenauer's essay documents the Biennial's historical memory, setting it in the context of Yugoslav and Slovene history and society. This is followed by the main section, devoted to the exhibition *Interruption*, which starts off with an essay by curator Deborah Cullen. The central pages then present the 42 art projects in this year's Biennial. *Interruption* also includes two in-depth essays on the work of the two artists who won awards at the

29th Biennial: Regina José Galindo was the recipient of the Biennial's Grand Prize, while Miklós Erdély's project *Unguarded Money*, 1956, received the Honourable Mention. Yasmín Martín Vodopivec acquaints readers with a large part of Galindo's oeuvre, while Annamária Szőke presents a thorough analysis of selected works by Erdély. Although the previous Biennial was particularly radical in its shift away from the medium of printmaking and its thematisation of the art event, the institution (introduced in 1969) of presenting awards as part of the Biennial's structure was nevertheless preserved. This has proved to be a way of always ensuring an inspiring overlap between the previous and current exhibitions. For the 30th Biennial of Graphic Arts, too, the two exhibitions of work by the award-winners have turned out to be a remarkable supplement to the Biennial's central theme: Regina José Galindo's artistic medium is merely her own body as the most primary form of expression and communication, while the artist, thinker, and visionary Miklós Erdély was convinced that the potential of art and science must be sought in their holistic connection.

Nevenka Šivavec
Director, The International Centre of Graphic Arts

10

The Biennial of Graphic Arts—Serving You Since 1955

Petja Grafenauer

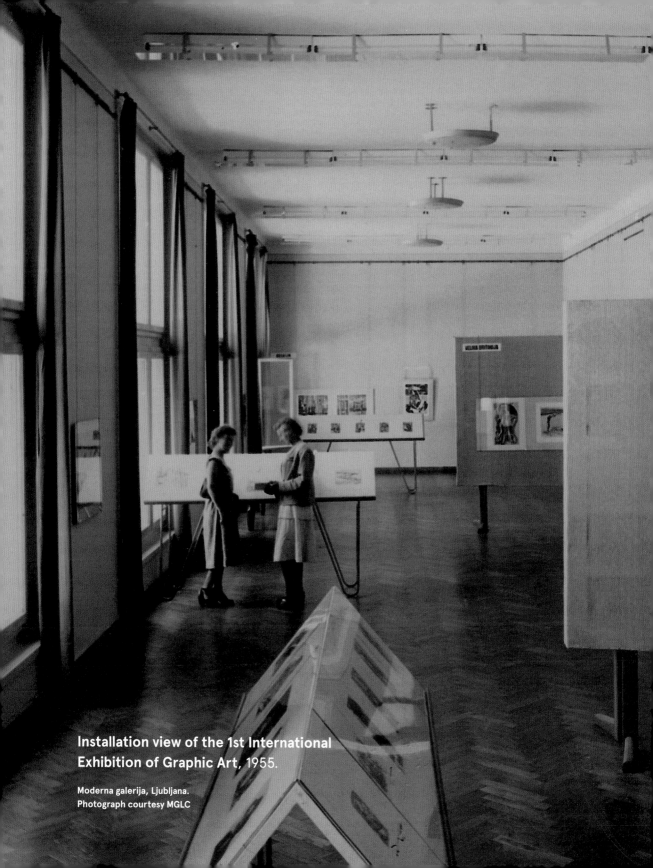

Installation view of the 1st International Exhibition of Graphic Art, 1955.

Moderna galerija, Ljubljana.
Photograph courtesy MGLC

13

Since the 1990s, the world has seen an upsurge in art biennials, for the most part in cities outside the world's major art centres. As Zoran Kržišnik, the founding father and long-time director of the Biennial of Graphic Arts Ljubljana, did more than half a century ago, enterprising individuals in other regional centres have come to feel that having a biennial was the right answer for places without the context or mature institutions for a year-round high-quality contemporary art programme. Because biennials interact directly with the local art world, they can create a discourse that penetrates the wider social sphere: "The relationship between the biennial and the public constitutes the dynamism that should be central to the production of an artwork: the collective imagination." And this dynamism, through the biennial, goes on working in the public sphere, which is continually being created as "a process, a movement, ceaselessly generating times and spaces in which people can share their intellectual and spiritual interests—in which they can, most importantly, contribute to a process of redefinition of the society in which we want to live".[1]

This is exactly what Ljubljana's Biennial of Graphic Arts has been doing since 1955. Through its uninterrupted work, it has been an engine for the local art world, and not only that. Initially with a distinctly modernist concept permeated by a humanistic, encyclopaedic desire and supported by political and, later, economic aspirations, and in recent years with a more democratic framework (if reduced support), the Ljubljana Biennial, from the time of the Cold War and Iron Curtain to today, has been a meeting place for artists, gallerists, critics, and collectors from East and West and from North and South. The local public was ready for this event. The print, the most democratic and most accessible artistic medium, became part of the life of the socialist citizens of Yugoslavia on many levels. It found a place on the walls of their living rooms. It followed them through the monotonous halls of

1 Hou Hanru, "Reinventing the social", *The Exhibitionist*, no. 6, June 2012, pp. 47, 49.

companies that echoed with the noise of typewriters. Their children learned about it on field trips to galleries, and again when Comrade Teacher put a little knife in their hands and taught them how to cut into linoleum. In the summer months, they would buy a train ticket using the discount the state railways offered to those attending the print biennial and they would walk along the promenade to the big event, which was for them a kind of United Nations in art. They saw that prints by Slovene artists were not all that different from those from the West—and this too gave them a sense of where they belonged. They could feel that they lived in a society that was so open it offered its hospitality to the whole world—and they forgot all those times things seemed otherwise.

The exhibition *The Biennial of Graphic Arts—Serving You Since 1955* presents the history of the event; it is not a walk down memory lane, but rather an active reminder of what is best about Ljubljana's graphic arts biennial. It presents a selection of works that shaped the Biennial, and makes use of images and other remnants time has left behind, while at the same time, through contemporary methods, it tries to show visitors that art is also part of everyday life today, and that this too is a way to create the society we want to live in. For this reason, two new works, made especially for the exhibition by the Slovene artists Viktor Bernik and Jasmina Cibic, are another important segment of the show.

Even in its beginnings, the story of the International Biennial of Graphic Arts in Ljubljana harbours a desire to be myth. The circumstances in which the Biennial was born and evolved, its chosen points of emphasis, its vitality, and, above all, the vastness of the event, which throughout its existence has had to struggle for better conditions, make the Biennial's 'backstage' story so multifaceted and, in many places, so mythologised that it is impossible to simply recount the history the way it happened. The two previous attempts at historicising the event—that of art historian Breda Škrjanec in 1993[2] and a collection of essays published under the

14

2 Škrjanec, Breda, *Zgodovina ljubljanskih grafičnih bienalov*,
 Ljubljana: Mednarodni grafični likovni center, 1993.

title *Mnemosyne* in 2010—were quite successful, but even so, given such a wide-ranging event, certain stories remain not fully told.[3]

The primary sources and documentation for the Biennial are scattered between the Moderna galerija (Museum of Modern Art), where the 1st International Exhibition of Graphic Art was born in 1955; the International Centre of Graphic Arts (known by its Slovene initials as the MGLC[4]), which in the late 1980s became the home of the Biennial (and Slovene printmaking in general); and Radio-Television Slovenia, whose archives hold valuable recordings, news reports, and even clips of live transmissions from openings of this international event. Precious sources have for decades been hidden away in personal archives as well, but these are not yet accessible to researchers.

Discussing the event's vibrancy and the ceaseless work that was presented to the public in two-year cycles, the Biennial's founder, Zoran Kržišnik, wrote in 1987 that, in future years, one of the goals would be to organise an archive. The embryo of such an archive already existed at the time, since a number of artists had offered prints to the Biennial as permanent donations:

15

[This collection] will be supplemented by prints from current and future biennials, which artists will present to it, and we hope that artists will also respond to our invitation concerning past biennials and provide prints to fill in still-existing gaps. The essential thing will be documentation that covers the whole of post-war printmaking and that will at every moment be available through computer processing to provide whatever information is needed for scholarly efforts or practical concerns.[5]

Kržišnik's wish was never sufficiently realised, and a collection of artworks that fully reflected the number of artists who participated at

3 *Mnemozina, čas ljubljanskega grafičnega bienala*, Vesna Teržan ed., Ljubljana: Mednarodni grafični likovni center, 2010.

4 Mednarodni grafični likovni center.

5 Kržišnik, Zoran, "Uvodna beseda", *17. mednarodni bienale grafike / International Biennial of Graphic Art / Biennale internationale de gravure*, Ljubljana: Mednarodni grafični likovni center, 1987, p. 7. The original Slovene quotation has been retranslated for the present text.

the Biennial, and the countries they represented, was never created. Collecting prints was not the Biennial's primary purpose. Even so, into the late 1980s, a collection did develop through spontaneous donations and gifts. The most important of these—a donation of 17 prints from top international artists—dates back to the 3rd Biennial, in 1959; it was made to the Moderna galerija by the Zurich publisher Oeuvre Gravée in recognition of its efforts in developing international printmaking. When the Biennial found a home at the International Centre of Graphic Arts in the 1980s, the availability of the printmaking workshops in the renovated Tivoli Mansion offered a chance for the Biennial to develop its collection, but for various reasons it did not take full advantage of this. In Slovenia, the socio-political situation made the development of a transparent art market impossible until 1990s, and even after entering the capitalist system, this question remained structurally unaddressed. In her 1993 history of the Biennial, Škrjanec drew attention to the difficult financial situation and "the greater or lesser antipathy of Slovenia's cultural policy [towards the Biennial]".[6] When the very survival of the Biennial was in doubt every two years, there could be no thought of it compiling a complete archival print collection. Still, it has been possible to put together an (incomplete) picture of the Biennial with a selection of prints from, mainly, the collections of the MGLC and the Moderna galerija in Ljubljana; the Museum of Contemporary Art in Belgrade, too, came to our assistance with its print collection. Helping to complete the picture from the early years, when the Biennial was still taking shape, is the art collection of the Adriatic Slovenica, which holds the posthumous papers of the Biennial's second father, Božidar Jakac—a first-rate Slovene artist and the founder of Ljubljana's Academy of Fine Arts and Design, Jakac had also been a member of the partisan resistance in World War II and was a friend of Josip Broz Tito, the president of Yugoslavia. Access to Kržišnik's papers, unfortunately,

16

Škrjanec, *Zgodovina ljubljanskih grafičnih bienalov*, p. 39.

remains an unanswered question, while future generations are left the task of researching the purchases and purchase awards of state, national, and municipal institutions as well as those of numerous Yugoslav and Slovene companies. In this connection, sadly, we must say that the ties between art and the business world woven by the Biennial under Kržišnik's leadership have largely unravelled in the new socio-political situation and with changes in the management personnel of commerce and industry.

In the early 1950s, when, after the initial period of Tito's split with Stalin, Yugoslavia was trying to rejoin the leading currents of Western art, Jakac returned from the woodcut exhibition *Bianco e nero*, in Lugano, Italy, with the idea of organising something similar in Ljubljana.[7] The decision to do a print show made strategic sense for several reasons: delivery and insurance costs were relatively low; Slovenia already had a somewhat developed print tradition; and printmaking had flourished during the partisan resistance (as Jakac himself had experienced). Of particular importance, too, was the fact that certain Slovene artists abroad had already shown support for printmaking and the idea of an international print biennial in Ljubljana.

17

When it came to selecting the town where this exhibition would be organised, we naturally thought of Ljubljana. Not only because this city is the actual centre of Slovene art-making—including printmaking—with suitable exhibition spaces at the Moderna galerija, but it is also at the same time an interesting tourist centre with an already international reputation, where visits by foreigners have increased so much in recent years that an international public is being created spontaneously.[8]

The 1st Exhibition of Graphic Art opened at the Moderna galerija in Ljubljana in 1955 almost at the same time as the city's new

7 Kržišnik, Zoran, "Ob jubilejni 25. postavitvi", opening
 speech at the 25th International Biennial of Graphic Arts,
 10 June 2003, typescript held at the MGLC, Ljubljana.
8 Kržišnik, Zoran, "Uvod", *I. mednarodna grafična razstava /*
 1ᵉ Exposition internationale de gravure,
 Ljubljana: Moderna galerija, 1955, n.p.

Trade Exhibition Centre opened; that was where a number of "first exhibitions" were held all in the same year: the 1st International Exhibition of Packaging, the 1st Tourist Exhibition, the 1st International Wine Exhibition, the 1st International Exhibition of Wood Processing, and so on. It was a time that favoured new beginnings, a time of new openness to the world. In 1952, the Yugoslav art scene had for the first time taken part in the Venice Biennale, which the Moderna galerija's first-ever director, the young Zoran Kržišnik, had attended as an assistant to the commissioner of the Yugoslav pavilion. As Kržišnik recalled in an interview towards the end of his life:

In Venice, where I was an assistant to Commissioner Šegedin in 1952, I met Zoran Mušič and we began talking about how the conditions had loosened up a little. When Mušič received an award in Cortina d'Ampezzo in the form of a stipend for Paris, he invited me to go there as well. So I went to Paris to meet with artists—on that occasion, the trip was, in a way, outside of my official connection, the Moderna galerija—and it was there that in fact we organised our first print biennial. What I mean is, it was in Paris that I collected 144 prints—the entire École de Paris, as it were—and 'smuggled' them back to Ljubljana. This formed a kind of basis, the foundation of the biennial. Various curators and directors of institutions started showing up at viewings in Ljubljana—for example, Gustave von Groschwitz, the director of the print biennial (for colour lithography) in Cincinnati…. [A]t that time, Arnold Bode, the organiser of documenta, also came to Ljubljana. He and I talked a great deal. I explained to him my idea about the Ljubljana print biennial and he explained his idea about documenta…. Just like curators today, I knew very well back then, too, that, if I wanted to launch a biennial, I would have to have already lined up, for instance, the entire École de Paris as a kind of 'calling card' that would open doors and ensure that others would want to work with us. And indeed, on the basis of my so easily acquiring the prestigious École de Paris, 12 countries said they would take part in the exhibition. If you compare this with the

18

creation of some similar contemporary event, like Manifesta for example, I don't see any substantial difference between the two.[9]

To convince politicians sceptical about modern art that the Biennial deserved their support, Kržišnik went so far as to host the Yugoslav vice president and minister of culture in Ljubljana and even took them to Paris and Venice.[10]

At the first biennial show, which was also the first international exhibition organised by the Moderna galerija, a total of 25 countries took part—from both Eastern and Western Europe, as well as the Soviet Union, the United States, Japan, and South Africa—and artists presented nearly 700 prints. Apart from the prints of the École de Paris, with Picasso as the main attraction, the works reached the exhibition in various ways, primarily through different official national representative bodies (at that time the exhibition had hopes of becoming a triennial event). Even then, Kržišnik knew the importance of personal contact with artists:

19

Nevertheless, already in the preparations for this exhibit, certain aspects arose that we will try to consider and to develop in the coming years so our future exhibits look as much as possible like what they would be if we had selected the works directly from the artists while visiting their studios.[11]

At the same time, the Biennial did not forget the public and made sure the event was well promoted through printed materials and discounts (visitors got a special discount on the train if they showed their ticket from the Biennial), as well as through public lectures and presentations that introduced people to graphic art.

The only criterion recognised by the Biennial was the principle of quality, which was kept to an international standard by a jury made

9 Kržišnik, Zoran, "Intervju z Zoranom Kržišnikom", interviewed by Beti Žerovc, 29th Biennial of Graphic Arts website (Slovene version), http://29graficnibienale.wordpress.com/zgodovina/intervju-z-zoranom-krzisnikom/ (accessed 13 May 2013).

10 Kržišnik, Zoran, "Pogovor z Zoranom Kržišnikom", interviewed by Beti Žerovc, in Beti Žerovc, *Kurator in sodobna umetnost: Pogovori*, Ljubljana: Maska, 2008, p. 46.

11 Kržišnik, "Uvod", *I. mednarodna grafična razstava*, n.p.

up of the artists Aldo Patocchi and Božidar Jakac and the critics and curators Aleks Čelebonović, Giuseppe Marchiori, Karel Dobida, and Kržišnik. The Biennial was put together by a ten-member Organisation Committee composed of Slovenia's most prominent artists and art historians. Nor did it hurt that the event received official endorsements from the ambassadors of France, Italy, Belgium, both Germanys, Poland, Turkey, Canada, Switzerland, Bulgaria, Romania, Finland, Hungary, the United Kingdom, the Soviet Union, and Czechoslovakia, as well as from the presidents of the executive councils of both the Federal People's Republic of Yugoslavia and the People's Republic of Slovenia along with other leading republican and municipal politicians. It was also endorsed by the well-known Serbian painter Marko Čelebonović, in his role as secretary general of the Yugoslav Artists' Union, and the former Surrealist writer Marko Ristić, who after the war had won the chairmanship of the Committee for Cultural Relations with Foreign Countries, which oversaw the movement of exhibitions across Yugoslavia's external borders.

And if, in that period, politicians came to the aid of art, it is clear that they were also aware of the reciprocal political importance of cultural events:

20

> The invitation to participate [in the 1st Exhibition of Graphic Art] was met by a willing response from a significant number of prominent artists in the Western world; meanwhile, because of our country's unique political position it was also possible for graphic artists from Eastern Europe's people's democracies to participate in the exhibition as well. Their participation is an important achievement by the organisers, for which the credit must go above all to the independent and peace-loving policies of Yugoslavia as a country.[12]

12 Vidmar, Josip, untitled welcoming speech, *I. mednarodna grafična razstava / Iᵉ Exposition internationale de gravure*, Ljubljana: Moderna galerija, 1955, n.p.

The invitation to take part in the first exhibition had gone out to artists from countries with which Yugoslavia had cultural and political ties, but "it was not possible to influence the participation of countries from the Eastern bloc, since the artists were chosen and sent by these countries' representative bodies".[13]

For the second exhibition, in 1959—where among the numerous participants we can find the names of Arp, Chagall, Clavé, Dix, Dubuffet, Hartung, Jorn, Marini, Miró, Picasso, Soulages, and Zadkine—the invitations were made to artists both personally and through the mediation of representative bodies. Given the large demand, however, an international competition was also introduced. An advisory role was assumed by an international board that included Jean Leymarie, the curator at the Museum of Grenoble; Émile Langui, a promoter of Belgian art; the Venetian art critic Giuseppe Marchiori; WJ Sandberg, the director of the Stedelijk Museum in Amsterdam; and Mieczysław Porębski, the director of Warsaw's Academy of Fine Arts, among others. The Biennial's most notable juries, however, were assembled in the late 1960s and 1970s, when the Stedelijk's director, Edy de Wilde, and the director of the Nuremberg Kunsthalle, Dietrich Mahlow, would travel to Ljubljana to take part. Joining them on the jury in 1969 was the Swiss curator Harald Szeemann, while William S Lieberman would travel from the Museum of Modern Art in New York, where he was the head of the Department of Drawings and Prints; after 1969, when he became the director of the Museum's Department of Painting and Sculpture, his place on the jury was taken by MoMA's Riva Castleman.

Many curators, museum custodians, art historians, and art critics would return to the Biennial again and again. They would be serving in various organisational capacities or, from time to time, simply came to visit their friend Zoran Kržišnik. And in this way they sustained, renewed, and expanded the network of those who created the Ljubljana Biennial of

21

13 Škrjanec, *Zgodovina ljubljanskih grafičnih bienalov*, p. 9.

Graphic Arts, while at the same time, through exchanges and organised exhibitions, they enriched the Slovene art world and influenced artists in the local scene. One such visitor was Walter Koschatzky, the director of the Albertina in Vienna; in his memoirs, he recalled:

> I had at the time, a few months earlier, in May to be precise, been invited for the first time to participate on the jury of the graphic biennial in Ljubljana. That was the beginning of a long-lasting friendship with Zoran Kržišnik, a colleague whose efforts on behalf of the rise and international recognition of the modern print was, and is, altogether invaluable. He opened wide the doors for this art, which we were both convinced was the most contemporary and, therefore, certainly also the most important art of our generation.[14]

Alongside the great names of Western art, visitors to the Biennial saw works by artists who could not be seen anywhere else. The Biennial of Graphic Arts had the good fortune

22

> to present in the same exhibition rooms the creative work of contemporary Western and Eastern artists at a time when such encounters were still infrequent…. But whereas at the first and second Biennial the word 'East' meant primarily the countries of Eastern Europe, its meaning has now widened and the Biennial includes not only European and American artists but also many works by exhibitors from the Far East and the Middle East, as well as from Africa.[15]

Here the Biennial's concept fully corresponded to the kind of politics that was being pursued by Yugoslavia and that, at a conference in

14 Koschatzky, Walter, *Faszination Kunst: Erinnerungen eines Kunsthistorikers*, Vienna: Böhlau, 2001, pp. 204–205.

15 Kržišnik, Zoran, "Uvod", *V. mednarodna grafična razstava / Vᵉ Exposition internationale de gravure*, Ljubljana: Sekretariat za organizacijo mednarodnih grafičnih razstav, 1963, p. 7.

1 Robert Rauschenberg
 Accident, 1963
 Lithograph, Universal Limited Art Editions
 Edition of 91/250
 97.3 x 70 cm
 Courtesy MGLC

2 The jury for the 3rd International Biennial of Graphic
 Arts, 1959: left to right, Mieczysław Porębski (Poland),
 Jean Leymarie (Belgium), Nobuya Abe (Japan), Giuseppe
 Marchiori (Italy), and Peter Floud (United Kingdom).
 Photograph courtesy MGLC

3 Raymond Pettibon
 Plots on Loan, 2001
 Artist's book (lithographs)
 49 x 36.5 x 2.5 cm
 Published by Brooke Alexander
 and David Zwirner, New York
 Courtesy MGLC

4 President Tito visits the Ljubljana Biennial, as reported
 in the newspaper *Ljubljanski dnevnik*, 24 July 1959
 Clipping courtesy Dnevnik d.d., Ljubljana

5 Zoran Kržišnik and Pierre Restany
 in jury discussions, 1985
 Moderna galerija, Ljubljana
 Photograph courtesy MGLC

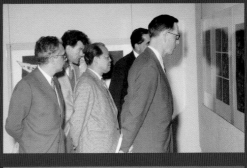

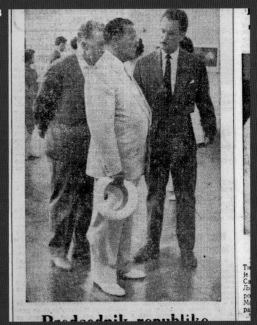

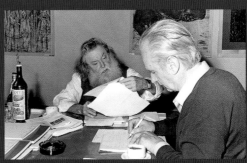

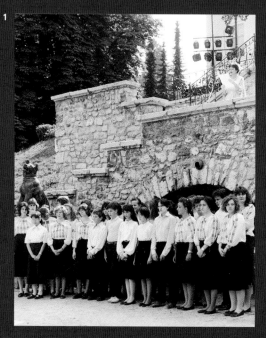

1 The opening of the 18th Biennial of Graphic Arts in 1989, with a women's chorus and actor Polona Vetrih in front of the International Centre of Graphic Arts. Photograph courtesy MGLC

2 Installation view of the 25th International Biennial of Graphic Arts, curated by Christophe Cherix, at the Cankarjev dom Gallery, Ljubljana, 2003. Photograph courtesy MGLC

3 A telegram from Zoran Kržišnik informing François Morellet that he has won an award at the 9th Ljubljana Biennial, 1971. Courtesy Moderna galerija, Ljubljana

4 Zoran Kržišnik, at the 26th International Biennial of Graphic Arts, *Thrust*, 2005. Photograph courtesy MGLC

5 Pedro Hanne Gallo
Sorrow in Vietnam, 1965
woodcut
53.2 x 35 cm
Courtesy MGLC

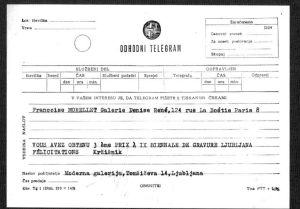

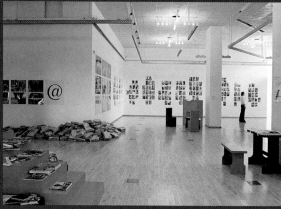

Belgrade in 1961, had developed into the Non-Aligned Movement. Already in 1959, President Tito had publicly praised Ljubljana's Biennial, even as he made it clear that he was still a man of the people: "It's marvellous that we have this gathering of artists from all over the world. New currents are being established, though I don't completely understand them. I feel closer to the kind of thing Jakac paints."[16]

For the political leadership, the Biennial represented a space that showed the openness of Yugoslavia, while at the same time people from opposing camps could meet here "freely and easily". Zoran Kržišnik recognised the power of political authority and successfully turned it to his advantage. One after another, visits to the Biennial by domestic and foreign leaders were announced and advertised in the media. In 1975, meanwhile, the 9th International Biennial of Graphic Arts, which coincided with the 20th anniversary of the work of the Secretariat for Organising Biennials and International Print Exhibitions and the 30th anniversary of Yugoslavia's liberation, enjoyed the highest possible patronage, that of the President of the Socialist Federal Republic of Yugoslavia, Josip Broz Tito.

The close ties between politics and art can also be seen in the visit of the Italian Prime Minister, Amintore Fanfani, to the Biennial. As Kržišnik later recalled, Fanfani was

25

a 'Sunday painter', and indeed such a good one that I personally invited him to our Biennial and he actually exhibited his work. During the Biennial he came to Ljubljana to see the show and at dinner he said to me, 'You know, I didn't come here only to look at my exhibitions but to ask if you could help put me in touch with your Tito. The situation today is such that we on the right and those who are open on the left have to start talking to each other.' I found a contact [for him] through Stane Dolanc, who was fairly open to things of this sort.[17]

16 Quoted in a caption to a photograph of Tito with the note
 "(statement from 1959)", *Dnevnik*, 25 May 1977, p. 5.
17 Kržišnik, "Pogovor z Zoranom Kržišnikom", p. 46.

Good relations with its supporters allowed the Biennial to openly follow what was happening in international printmaking. Probably the Biennial's biggest event (which, however, achieved fame only a year later, when the winners of the Venice Biennale were announced) was the awarding of the Grand Prize to Robert Rauschenberg at the Ljubljana Biennial in 1963. Sitting on the jury that year was the American William Lieberman. Several years earlier, Lieberman had advised the Russian émigré Tatyana Grosman—who, needing to earn money after her husband became ill, had opened a fine art printing press on Long Island—that she should print new works by young artists rather than Chagall reproductions. Mme Grosman then invited Jasper Johns to work in her studio and through him met Robert Rauschenberg, which paved the way for Universal Limited Art Editions to enter the printmaking world. Rauschenberg's award-winning print *Accident*, which had come to Ljubljana with the help of ULAE, found itself part of the most complex Biennial so far. The prints exhibited that year in Ljubljana included works by Alberto Burri, David Hockney, Emilio Vedova, Getulio Alviani, Jasper Johns, Karel Appel, Ossip Zadkine, Robert Motherwell, Victor Vasarely, and others, who were presenting Optical Art, the New Abstraction, the art of social reportage, Pop Art, and European New Figuration.

In the jury's opinion, however, Rauschenberg's *Accident* was truly something special, and the assessment they made in Ljubljana concorded with that of art history—and may even have somewhat shaped it. As Deborah Wye observes:

> [Rauschenberg's] daring use of lithography appeared early on, when the stone for *Accident* broke in two.... Undeterred, he retained the diagonal white gash through the composition, recording this event. When *Accident* won first prize at the prestigious Ljubljana Graphic Biennial in 1963, it established

26

Rauschenberg, ULAE, and American printmaking in the forefront as never before.[18]

Right through the late 1970s, at least in the politics of its awards, the Biennial was a characteristic piece in the mosaic of modernism, such as was dictated by the world's wealthiest nations. In 1993, in the catalogue for the 20th International Biennial of Graphic Arts, which attempted to make an audit of the event's history, Riva Castleman wrote: "Inevitably, it was the artists of Capitalist countries whose artistic expressions were honoured by the Biennial judges. This, of course, was one consequence of art representing national policy, and the method of selection (by country) perpetuated the situation."[19] Even so, today we can also say that one of the most valuable aspects of the Biennial has in fact been the presence of prints from countries that were not part of the proclamation of the Western Canon, or that at most only flirted with it from time to time.

The 1960s saw an increase in the number of awards presented by the Biennial. From the beginning, the bylaws had stated that the Biennial would mediate the sale of works, and from the 1960s on, the range of its awards expanded to include not only prizes presented by state and cultural institutions but also purchase awards and donations from companies, sponsorships, and other forms of collaboration.[20] In some years, when Yugoslavia was experiencing times of prosperity, it seemed that nearly all of Slovenia's most prominent companies appeared on the list of Biennial supporters. As prints became more popular, however, the market was flooded, and by 1993, Kržišnik was warning about the

27

18 Wye, Deborah, *Artists and Prints: Masterworks from The Museum of Modern Art*, New York: The Museum of Modern Art, 2004, p. 150.

19 Castleman, Riva, untitled statement, *20. Mednarodni grafični bienale / International Biennial of Graphic Art*, Ljubljana: Mednarodni grafični likovni center, 1993, p. 236.

20 In 1957, the main award was worth 250,000 Yugoslav dinars; in 1959, 300,000 dinars; in 1969 (after the revaluation of the currency), 10,000 new dinars; in 1973, 15,000 new dinars; in 1975, 17,000 new dinars; and in 1977, 18,000 new dinars. "At the time of the introduction of standardised wage rates in 1950, the average monthly salary was around 4,000 dinars; by 1961, this had risen to 27,200 dinars, and in 1965, when the new denomination at a ratio of 1 : 100 was implemented, the average monthly salary was 623 new dinars. By 1970, salaries had doubled, and the average was 1,373 dinars. These salaries doubled again in less than four years, and in 1974, the average was 2,815 dinars. Again they doubled in less than four years, and in 1978, the average was at 5,903 dinars." (Kresal, France, "Mezde in plače na Slovenskem od novele obrtnega reda 1885 do kolektivnih pogodb 1991", *Prispevki za novejšo zgodovino*, vol. 35, nos. 1–2, 1995, pp. 22.)

negative aspects of this popularity: "The print has become the object of speculations that, through various machinations, are setting prices for graphic art that have nothing to do with its value."[21]

The Biennial soon outgrew its architectural parameters and by 1969 a large number of the prints submitted to the competition had to be excluded due to a lack of space. Kržišnik, looking for a way to extend the Biennial to Bled, a major Slovene tourist attraction, drew up plans for the Ljubljana–Bled Print Studio, which would have presented concurrent programmes for local and foreign artists. This idea was never realised, but in 1979, the Biennial announced:

> The new international graphic centre we are planning in Ljubljana, with its permanent print collection, printmaking workshop, ties with a press, etc., will open new spaces for presenting achievements in printmaking, for work meetings with artists from as many countries as possible, for stimulating gifted artists from developing countries…. We hope that the very next International Biennial of Graphic Arts, the 14th, will be held under [the centre's] auspices.[22]

28

Given the importance of the graphic art biennial, the Moderna galerija, which had hosted the event from its founding, was reorganised in the 1980s into three working units: the Museum of Contemporary Visual Art, the International Centre for Graphic Arts (the MGLC), and an exhibition unit.[23] As museum consultant Jana Intihar Ferjan recalls, "The work at the Moderna galerija was in those days run autocratically, but it was carried out in a self-management style. A small group of us

21 Kržišnik, Zoran, "Uvod", *20. Mednarodni grafični bienale / International Biennial of Graphic Art*, Ljubljana: Mednarodni grafični likovni center, 1993, p. 6. The original Slovene quotation has been retranslated for the present text.

22 Kržišnik, Zoran, "Beseda za uvod", *13. mednarodni bienale grafike / 13. Biennale de gravure Yougoslavie / 13th Biennial of Graphic Art Yugoslavia*, Ljubljana: Sekretariat za prireditev bienal in mednarodnih grafičnih razstav, 1979, p. 9. The original Slovene quotation has been retranslated for the present text.

23 Intihar Ferjan, Jana, and Bojana Rogina, "Moderna galerija. Kronologija", *Čestitke, obračuni in načrti. 60 let Moderne galerije*, Ljubljana: Moderna galerija, 2008, p. 28.

resisted when the MGLC was being set up and we were summoned to personal interviews."[24]

Renovations on Tivoli Mansion, where the now-independent unit of the MGLC was installed, were completed in 1987, and the building was officially opened at the next Biennial. The renovation costs had largely been covered by "respected and successful Slovene companies with sponsorship funds, for which they received the thanks of visual artists in the form of donated prints".[25]

In the decades since its founding, Ljubljana's Biennial of Graphic Arts has inspired the creation of many similar events in other cities—Grenchen, Switzerland, in 1958; Tokyo in 1965; Krakow in 1966; Florence in 1968; Bradford, UK, in 1970; Fredrikstad, Norway, in 1972, and elsewhere. The connection with Japan was particularly resonant. Many excellent prints came to Ljubljana from Japan, and numerous collaborations developed, so much so that the Slovene organisers of the Biennial felt "entirely at home" at the Museum of Modern Art in Tokyo.[26] In the early 1970s, Japan's participation in the Ljubljana Biennial was described as an explosion of new possibilities, in both quantity and quality. And at the end of the decade, Kržišnik was praising the Yugoslav and Japanese artists, who "had no interest in the somewhat sentimentalised academicism which, because of the large number of such contributions by Western artists, gives the 13th International Biennial of Graphic Arts in Ljubljana its distinctive image".[27]

In 1971, in conjunction with the Biennial, an international symposium was held, under the auspices of the International Association of Art Critics (AICA), where it became clear that printmaking was moving away from its traditional commitment to classic printing methods. At AICA's general

29

24 From an interview with Jana Intihar Ferjan, museum consultant for documentation and archives, 8 June 2009, in Ljubljana; the dictaphone recording is held by the author. The reasons for the discontent require further investigation and explanation, but from the existing interviews it is clear that at the time all energies at the Moderna galerija were focused on the creation of the graphic art centre, which meant that exhibition work, museological research, and documentation work suffered.

25 "Eksperimentalni atelje. Oddolžitev sponzorjev z grafikami", *Dnevnik*, 30 January 1988, p. 16. See also "Bienale in Mednarodni grafični likovni center. Sponzorji omogočajo obnovo Tivolskega gradu", *Dnevnik*, 24 December 1986, p. 12. The Moderna galerija continued to provide space for the Biennial of Graphic Arts right up to 2005, when its decision to end the collaboration prompted renewed calls for a suitable space for the Ljubljana Biennial.

26 Kržišnik, "Intervju z Zoranom Kržišnikom".

27 Kržišnik, "Beseda za uvod", *13. mednarodni bienale grafike*, p. 9.

assembly in Zagreb in 1973, questions were raised about the social role of printmaking, and that same year, the Slovene art historian Špelca Čopič made the fundamental observation:

> Because printmaking methods are being expanded, so too are the possibilities for applying the print base to new materials: printed wall decorations, printing on three-dimensional objects, print mobiles, film graphics, photo-graphics, computer graphics, which are also being offered to the Ljubljana Biennial.[28]

Already by the end of the 1970s, the Biennial was having to explain why it no longer presented the most innovative work in printmaking: "Our principle of openness, while it has not excluded works made using extreme approaches, has also not shown them preference, There have, indeed, been artists from certain radical trends who have received awards at the exhibition."[29] The Biennial found itself defending its selection and exhibition policies less and less successfully right up to 1991, when the Yugoslav balloon finally burst. Ljubljana's largest art event felt the crisis profoundly. It tried to preserve its basic structure by presenting an interesting side programme, but it was clear that a more fundamental change would be needed.

The times when the Biennial could present itself as an event that united East and West, that showcased new trends in graphic art every two years, that brought the First, Second, and Third Worlds to Ljubljana and did not discriminate between them (at least on the surface)— these times came to an end with globalisation and social and artistic pluralism. For the local art community, this meant the contraction of the printmaking's entire system (fewer state commissions, sales, donations, less attendance at exhibitions, etc.), which had, unfortunately, staked everything on a single card: the Ljubljana Graphic School. This group

30

28 Čopič, Špelca, "Ob deseti mednarodni grafični razstavi v Ljubljani", *Sinteza*, no. 28, 1973, p. 57. The original Slovene quotation has been retranslated for the present text.
29 Kržišnik, "Beseda za uvod", *13. mednarodni bienale grafike*, p. 5.

of printmakers, all of the same generation, had developed around the Ljubljana International Biennial of Graphic Arts and were only very gradually leaving positions of prominence in the local art world. And with its own change in leadership, the MGLC—after more than 20 years of receiving criticism about the Biennial—shifted in the direction that the Belgrade-based art historian Ješa Denegri had advised in 1991:

> But the very fact that graphic art is based on the principle of reproduction, that it can produce a greater or lesser number of identical samples, that it is in its very essence subject to multiplication—this fact in itself makes it an attractive medium to artists who no longer believe in the unassailability of the unique work, in the primacy of the original; artists for whom the work of reproducing a prototype is preferable to insisting on the unrepeatability of the initial work and to making other always-different works; for whom a way to produce a work-double is just what they want. For them, the graphic work is by its very nature an adequate duplicate, triplicate, *n*-plicate of the initial prototype.[30]

31

In 1999, the Estonian selector, Eha Komissarov, writing in the Biennial's catalogue, presented a critical text that exposed the event's problems:

> The senseless closing into oneself, caused by centering around the point made up of one's own traditions, has pointed out and clarified the dangers of cutting away one's basis. I am sure [that] graphic art, in order to survive, must become attractive to new coming generations, and must be ready for [the] languages that these generations use. Graphic art is related not only to the

30 Denegri, Ješa, "Grafika na začetku devetdesetih", *19. Mednarodni grafični bienale / 19th International Biennial of Graphic Art,* Ljubljana: Mednarodni grafični likovni center, 1991, pp. 9–10. The quotation has been retranslated from Slovene for the present text.

structures it is based on, but also to the structures that renew it. The new, liberalised regalements of big exhibitions that demolish contradictions around the idea of print and take into account technologies accommodated to new digital media, are a good example of successful strategies of fighting with crisis. I have nothing against an image that builds a graphic construction where graphic art would mean an unlimited number of independent units with their own language and grammar. Thus changing and preserving.[31]

In 1999, the Biennial for the last time heard criticism from international commentators: the next instalment did away with national presentations and opened the doors to an alternative understanding of graphic art. The central exhibition of the 2001 Biennial, *Print World*, was curated by the art historian Breda Škrjanec, who later wrote:

> The revitalisation of the *Biennial* is meant to be a process that probes the structure of the event, its internal organisation, its relations with domestic and foreign publics, and curatorial work. In shaping its concept, the International Centre of Graphic Arts has cooperated with domestic experts from several fields and from different generations, as well as with the international advisory board of the *Biennial*.[32]

The international public welcomed the event's transformation under the leadership of the MGLC's new director, Lilijana Stepančič; the Ljubljana Biennial even received an award for innovation from Spain's Calcografía Nacional, at the Real Academia de Bellas Artes de San Fernando in Madrid. A number of once-privileged artists and critics, however, were not happy about the competition being cancelled; at the

32

31 Komissarov, Eha, "Estonia", *23. mednarodni grafični bienale / 23rd International Biennial of Graphic Arts*, Ljubljana: Mednarodni grafični likovni center, p. 73.

32 Škrjanec, Breda, "Fifty Years of the International Biennial of Graphic Arts", *25th International Biennial of Graphic Arts, Ljubljana / 25. mednarodni grafični bienale, Ljubljana*, Christophe Cherix and Madeleine Goodrich Noble eds., Ljubljana: Mednarodni grafični likovni center, 2003, p. 30.

same time they felt threatened by the expanded concept of the print, which no longer retreated into the safe world of aesthetics but rather ascribed equal value to both printmaking and printing. As Škrjanec explained at the time: "I hold the opinion of those who say that the essence of graphic art is neither its multiplicity nor its originality. Its essence lies in the dual nature of the graphic work; this means that graphic art is something that has two opposite sides in the way it exists: a negative side and a positive side."[33]

Works by John Baldessari, Monica Bonvicini, Damien Hirst, Kurt & Plasto, Tracey Moffat, and Christopher Wool stood alongside projects by select Slovene artists, who no longer came from the tradition of the Ljubljana Graphic School but from the volatile network of contemporary art. When, at the next Biennial, the curatorial baton was passed to Christophe Cherix (today the chief curator of prints and illustrated books at MoMA in New York), his selection of works only further confirmed the ideas the institution was introducing. In 2005, Jure Mikuž, the former director of the Moderna galerija and a university professor, tried to calm local passions with the exhibition *Thrust*, in which, for the Biennial's 50th anniversary, he invited the world's most important graphic art centres to present selections of works that demonstrated what, to them, represented the essence of graphic art.

The Biennial's next instalment made connections with the local art scene, and two years later, this same local scene was given the role of being selectors for the Biennial, which, under the leadership of the Slovene art historian Božidar Zrinski, understood graphic art as a matrix for unstable reality. The 29th Biennial of Graphic Arts, entitled *The Event*, was curated by the art historian Beti Žerovc. She put together the first graphic biennial that turned away from graphic art altogether and chose as its theme something that, in the curator's opinion, was a key element in the world of contemporary art: namely, the event. As the media reported:

33

33 Škrjanec, Breda, "Print World", *24. mednarodni grafični bienale / 24th International Biennial of Graphic Arts*, Ljubljana: Mednarodni grafični likovni center, 2001, p. 63. The original Slovene quotation has been retranslated for the present text.

Beti Žerovc, explaining the reasons for such a turnaround, cites statements by the Biennial's founder, Zoran Kržišnik, to the effect that in the mid-1950s, when the International Biennial of Graphic Arts was founded, the decision to present graphic art was primarily a pragmatic one, since graphic art was more accessible for the organisers in terms of the expenses involved and at the same time its prices were more affordable for the wider public and collectors. According to Žerovc, the commitment of the Biennial's organisers to graphic art was never absolute and exclusive: their goal was a large international art exhibition, which in those days was most easily achieved by presenting works of graphic art.[34]

Whichever myth we choose to believe—whether that the decision to establish a Biennial of Graphic Arts was entirely pragmatic or that it was the result of the country's rich printmaking tradition, and above all the printmaking work of the partisans—the fact remains that, in the post-war years a single dynamic modernist figure organised an exhibition on the strength of his own desire, and from that event, in collaboration with many other individuals from the worlds of art, business, and politics, he wove a narrative that, as occasionally happens in art, has been able to survive his passing. After the 29th, we now have the 30th Biennial of Graphic Art, and the efforts of everyone involved continue to ensure that every two years in Ljubljana we again have an Academy (where teachers and students, immersed in conversation, stroll through the park towards the city), a Symposium (where new alliances and new ideas are born over glasses of wine), and a Platform (the exhibition spaces, where dozens of creative individuals send new ideas into the world and remind us of some we may have forgot). All of this together is the Biennial, which has secured Ljubljana a place on the art map of the world ever since 1955.

34

Translated by Rawley Grau

34 Kos, Albert, "29. Mednarodni grafični bienale", *Sinfo—Informativno-promocijska revija*, October 2011, http://www.ukom.gov.si/si/promocija_slovenije/ publikacije/sinfo_informativno_promocijska_revija/ arhiv_2011/sinfo_oktober_2011_mednarodni_graficni_ bienale/ (accessed 14 May 2013).

Interruption: Shadows in a Volatile World

Deborah Cullen

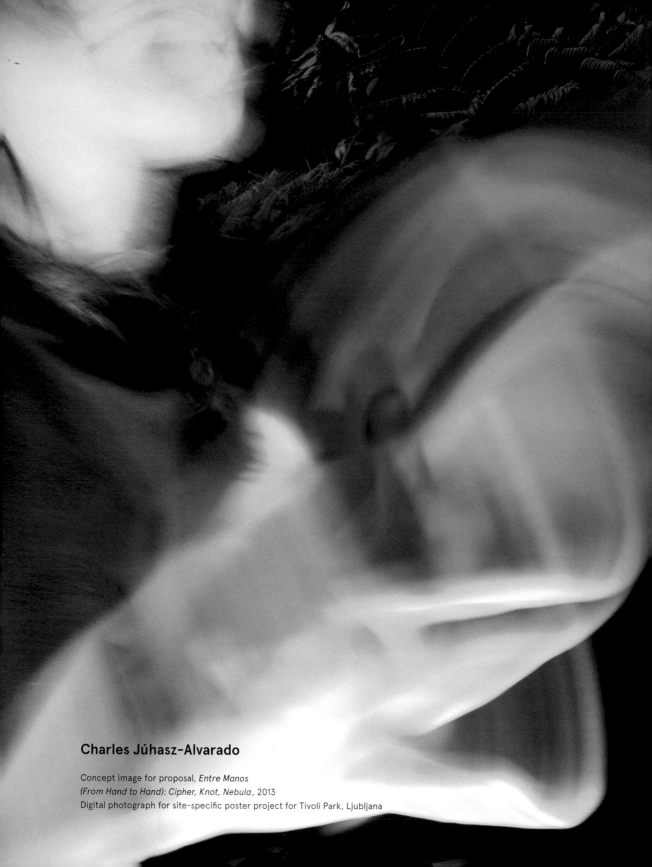

Charles Júhasz-Alvarado

Concept image for proposal, *Entre Manos*
(From Hand to Hand): Cipher, Knot, Nebula, 2013
Digital photograph for site-specific poster project for Tivoli Park, Ljubljana

*To them, I said, the truth would be literally
nothing but the shadows of the images.*[1]

I.

Plato utilised the analogy of shadows on the wall of a cave passing before
the eyes of captives to represent images we believe we understand but
really do not. These ghosts of images, while entertaining and seductive,
could also be deceptive. Easily manipulated, they were subject to artistry:
hands making bird wings, far from any aviary.

Plato's analogy was, in part, a meditation on the importance of
critical thinking. It maintains its significance even in our transformed
and digitised world, because the warning could just as easily apply to
mindlessly browsing the Internet and social media without employing
analytical skills: beguiling dispatches from unknown sources can cloud
our minds—or lead us to sudden, unexpected truths. While shadows
are alluring, we must be discerning and not accept what we see without
question. We must ask how the modes of communication themselves
play a role, thwarting or emphasising what we say. Plato's fable persists
because its warning remains relevant, even as our tools evolve.

The analogy also provides one of the first basic yet enduring
definitions of the print: an image created by a transfer process. The
shadows in Plato's cave were, we can say, ephemeral graphics. His caution
mirrors our hesitation before the significant transformations printmaking
has undergone in response to the new technologies that have taken strong
root particularly in the past decade.[2] Digital processes, improved printing
capacities, and the abilities of web-based and social media networks have

37

1 Plato, *The Republic,* Benjamin Jowett trans., New York: Vintage,
 1991, pp. 253–261; Plato's work was written around 380 BCE.
2 As early as 2001, the Brooklyn Museum of Art, in New
 York, presented *Digital: Printmaking Now*, by Marilyn S
 Kushner. A very good recent survey addressing this tension
 was *Print/Out: 20 Years in Print*, edited by Christophe
 Cherix, with contributions by Kim Conaty and Sarah
 Suzuki, New York: The Museum of Modern Art, 2012.

interrupted the path of traditional graphics, while also imparting new life to the medium, both technically and conceptually. A bold new polygraphic terrain now can be thought to include all reproducible, transferable, and serial projects.

Interruption, marking the 30th edition of the Biennial of Graphic Arts Ljubljana, considers the evolutionary graphic field of contemporary times. Print processes continue to touch many types of present-day art. Select, traditional media have evolved and adapted to maintain their relevance, while digital processes, after a long fermentation, have finally taken legitimate hold as artistic tools in their own right. *Interruption* surveys extensions of traditional techniques, as well as new approaches to printmaking that respond to our twenty-first century modes. Fresh applications of traditional media and innovative incorporations of new technologies attest to the lasting relevance of graphic processes.

As well, this is a selective survey that tracks and interrogates the ways in which our very means of visual literacy and daily communications have themselves been radically transformed. Works comment on how we now receive information, how we interact—or attempt to—with each other, how we (mis)perceive our world. Clamouring and unfiltered data bombards us. Masquerading commercial and political agendas vie for attention alongside personal thoughts and images that are more than we can ever possibly absorb. This hyperactivity of text and image begs our attention. While some artists respond by returning to basic, even primal, forms of image reproduction, others embrace the random, fractured, and endless virtual world. *Interruption* explores the graphic as both form and content, in an invigorated terrain that links the work of diverse contemporary artists from around the world.

38

II.

Even in these days of brightly flickering, mediatic bombardment, ghostly shades beckon. Meta Grgurevič and Urša Vidic create shadowplays with their mechanised theatres. Tiny, wondrous machines cast Chaplinesque doubles on fanciful scrims inside

funhouse environments. We cannot catch hold of their indexical images, but watch in the dark, awaiting their repetition.[3] We are hypnotised by the nostalgic, magical moving scenarios.

Other elemental approaches to graphic image-making persevere. Tomás Espina deploys fire, smoke, gunpowder, and other unstable substances to blast his haunting eruptions of danger within and upon architectural spaces. Volodymyr Kuznetsov, trained in textile work, choreographs a firing squad to pattern a luxury car with folk designs. Meanwhile, performer Venelin Shurelov lies inside a box covered with many tiny doors, which allow the public to draw on him piece by piece, thereby 'tattooing' his skin. Such direct and forceful activity remains satisfying in an era when we have fewer experiences of substance to grasp. The volleys of the gun or the sharp metal edges of bullet holes, the lingering acrid whiff of burning tar, or the image of a completely marked naked body confront us. They conjure our own very real, fleshy vulnerabilities.

There is a resurgence of traditional, or academic, printmaking techniques. The oldest of the graphic methods, relief, dates back over 1,000 years to China and includes wood engraving, wood- and linocut, stamping, and collagraph. Its directness appeals to Renata Papišta, who applies white, skull-like woodcut prints directly to walls: lined up across an expanse, piled like cannonballs, one alone lurks unexpectedly. Her ghostly apparitions dialogue with the customary and visceral purposes often linked to the woodcut, while also serving as a haunting form with which to address recent Bosnian history. In the Švicarija building in Tivoli Park, another type of woodcutting is going on. Thomas Kilpper turns the floors of buildings into large-scale woodcut surfaces from which he produces public banners that articulate these sites' complex, layered histories. He exploits the transitional status of these abandoned or not-yet-renovated spaces, while liberating their rich, fraught, and usually

39

3 Peirce, CS, "Division of Signs" (1897), *Elements of Logic*, vol. 2, *The Collected Papers of Charles Sanders Peirce*, Charles Hartshorne and Paul Weiss eds., Cambridge, MA: Belknap Press of Harvard University Press, 1960, pp. 227–273. Peirce defines an "index" as a sign linked to its object by a real relationship: smoke billowing from a house is an index for the fire inside. An "icon" is a sign linked to what it represents by some shared quality, such as a stick-figure man or woman. A "symbol" represents its denoted object through an interpretive but independent habit or rule, such as the word "horse".

secret trajectories. Relief encourages bold commentary on often-political topics.

Many artists continue to plumb the rich legacy of intaglio, invented in Germany in the early fifteenth century and persisting through engraving, etching, drypoint, aquatint, and other techniques. Mario Čaušić's painstaking drypoint explosions draw us in with a magnifying glass so that we might confront our own shocking boredom with images of such disasters. Alex Cerveny's precious *cliché verre* Pinocchio illustrations charm us, reminding us simultaneously of more innocent and more brutal times. Gorazd Krnc also works with illustrations. In his case, he recycles Old Master painting reproduction plates into an idiosyncratic, numerological worldview. Ana Golici, obsessed with a flea under a microscope, has lovingly crafted a wall-size, sandblasted glass mosaic of this lowliest of creatures. Ottjörg AC has spent years visiting schools around the globe, printing desktops that reveal the parallel joys and pains carved by far-flung adolescents. Their graffiti palimpsests poignantly remind us of fleeting time and the cycle of life. The precision of intaglio lets us home in with detail on nature, art, language, and literature.

Lithography, a relatively new technique invented in Germany only in the late eighteenth century, is a chemical rather than physical process; it includes the high-volume offset method, which is responsible for most of our commercially printed material. Milos Djordjevic turns a stack of solidly printed offset sheets into an ever-changing interactive game. Viewers participate by adjusting the abstract composition of positive/negative shapes formed by the dark sheets and white wall. He resensitises his public to the sheets they touch each day in books and newspapers. Printed matter has assumed greater importance within the graphic arts over the last 50 years. Agnieska Polska, on the other hand, appropriates available antique printed matter, recomposing elements from it in a collage-like manner to create meditative videos. Her repurposing of a broad range of printed matter as animations recycles these images into eerie new narratives.

André Komatsu makes high stacks of offset or Xerox-copied sheets. Printed with images culled from the Internet and dictionary

40

definitions, his barricade of seemingly random cultural ideas is blown to the floor by industrial fans. While referring to one of the basic ideals of print—that it is cheap and available to all, just as Internet information is to us now—Komatsu's endless images and sheets also comment on contemporary society's excess and waste. While the printed sheet was once a very special thing, it now threatens our rainforests and fills our dumpsites with an overload of information.

In the 1970s, a new type of experimentation with Xeroxing emerged, fed in part by Mail Art.[4] The Xerox Corporation even provided artists with residencies so they could experiment with the new technologies.[5] One of their heirs is Adam Pendleton, who combines photocopied images from various printed sources into puzzling, provocative, black-and-white silkscreened images. Pendleton searches for incident and surface, while investigating the junction of texture, tone, and visual language through his sleek collages. These combine disparate images from a range of geographic areas and time periods in a modernist formal language united by silkscreen. Although screen printing, or stencilling, first appeared over 1,000 years ago in China, it came to Europe only in the late eighteenth century, and was not broadly accepted until the late nineteenth century, when it began to be widely employed in industrialising nations.

41

More recent media allow artists to explore specific issues. The team caraballo-farman have been developing projects for several years around the imaging of breast cancer. They have transformed a personal experience with the disease into an artistic investigation to understand and extract versions of cancerous tumours. They use actual medical imaging, 3D printing, and modelling (at times translated into jewellery or pedestal-size sculptures), as well as sessions with a shaman, to visualise tumours, understand them, and expel them. Their UV blockout

4 Mail Art developed out of a playful Fluxus approach, but the practice flourished under the necessities of the Iron Curtain, as well as the cabal of the Latin American dictators, from the late 1950s well into the 1980s.

5 For a history of this endeavour, see *Art and Innovation: The Xerox PARC Artist-in-Residence Program*, Craig Harris ed., Leonardo Book Series, Cambridge, MA: The MIT Press, 1999. Although the PAIR programme was officially operational only from 1993 to 1999, Xerox began sponsoring artists much earlier. The Creative Artists Public Service Program (CAPS) in New York distributed some of the first Xerox fellowships, in 1973–1974, to artists Stephen Antonakos, Joan Snyder, Joel Swartz, Jack Whitten, and Robert Whitman. For a recent discussion of Whitten and Xerox, see Kuo, Michelle, "Jack Whitten—A Portfolio", *Artforum International*, February 2012, p. 195.

vinyl prints employ commercial signage processes to create highly detailed images.

Other artists consider architectural themes. Nicola López creates sprawling, graphic installations dealing with urban growth. She animates a suite of silkscreen prints with blue tape into a sequence incorporating iconic structures. Her irrational *Tower of Babel* rises and falls. Marjetica Potrč, an artist and architect, researches the renovation of Tirana's main streets and buildings after the fall of Communism in 1992. Her study—based on her participation in the *Lost Highway Expedition* through nine cities in the Western Balkans (Ljubljana, Zagreb, Novi Sad, Belgrade, Skopje, Prishtina, Tirana, Podgorica, and Sarajevo), which she co-organised—is presented, in part, in the form of photographic digital wallpaper and overlaying photo-drawings that discuss Tirana's brightly patterned facades.

Returning to wood, but in an up-to-date way, Tomas Vu-Daniel's hand-carved and laser-engraved wooden surfboards are complex objects that evoke his childhood in Vietnam. His loving snippets of The Beatles' song lyrics and marine-like fauna cover the boards' surfaces. They locate the work's subject historically and geographically, while suggesting conflicted memories of contact with American soldiers on his country's beaches. María Elena González also transforms wood into song. In her lyrical project, the bark of a fallen birch tree generated frottages, studies, and finally, drawings, which were scanned and laser-cut into a player piano roll. From this, she is able to play the modernist 'music' of the tree's natural patterns.

42

III.

Producing artwork with and through digital means is not a new phenomenon. As early as the 1950s, artists were experimenting with imagery produced by mainframe computers, especially in Germany and the United States. Beginning in 1961, the New Tendencies (NT) artists in Zagreb began experimenting with computer art. Through the NT movement and its supporting institution, the Galerija suvremene

umjetnosti (Gallery of Contemporary Art; today, the Museum of Contemporary Art–Zagreb), an international hub was created for exploring the intersection of art and technology in socialist Yugoslavia.[6] Founded the same year as the Non-Aligned Movement, NT undoubtedly benefited from its unique cultural time and place: artists and scientists from both East and West could meet at the height of the Cold War to create cutting-edge works.[7]

Meanwhile, in the summer of 1962, A Michael Noll at Bell Telephone Laboratories in Murray Hill, New Jersey, programmed a digital computer to generate visual patterns solely for artistic purposes.[8] The first two exhibitions of computer art were held in 1965: *Generative Computergrafik*, at the Technische Hochschule in Stuttgart, Germany, in February and *Computer-Generated Pictures*, at the Howard Wise Gallery in New York in April. A third exhibition occurred that same year in November, at Galerie Wendelin Niedlich, also in Stuttgart. In 1968, the Institute of Contemporary Arts in London hosted *Cybernetic Serendipity*, while the NT artists, in Zagreb, held a symposium entitled "Computers and Visual Research" and organised an exhibition of the same name.

43

This abbreviated review reminds us that traditional forms of printmaking have long co-existed with digital technologies. Nonetheless, they have only come into the general artistic conversation in the last 20 years and become ubiquitous as an artistic tool within the last ten, as personal devices have thrived and printer quality improved. Perhaps a 1992 project by artist Dennis Ashbaugh and writer William Gibson marked the moment in which print both embraced and questioned the role of technology in the rapidly changing art world. In the artist's book *Agrippa: A Book of the Dead*, Ashbaugh's lush yet traditionally

6 The best anthology on the subject is *A Little-Known Story About a Movement, a Magazine and the Computer's Arrival in Art: New Tendencies and the Bit International 1961–1973*, edited by Margit Rosen in collaboration with Peter Weibel, Darko Fritz, and Marija Gattin, Karlsruhe, Germany: ZKM/Center for Art and Media, 2011.

7 NT had three exhibitions in Zagreb: in 1961, 1963, and 1965. In 1968, they changed their name to "Tendencies" and launched the multilingual, ground-breaking journal, *Bit International* (it ran until 1973, with nine issues).

Their efforts received international attention, and during the early 1970s the group exhibited at the Louvre in Paris and the Museum of Modern Art in New York.

8 For a history of this innovative American company, see Gertner, Jon, *The Idea Factory: Bell Labs and the Great Age of American Innovation*, New York: Penguin Books, 2013. One of the Bell Labs pioneers was the Swedish electrical engineer Billy Kluver, who with Robert Rauschenberg, Robert Whitman, and others founded the influential group, Experiments in Art and Technology (E.A.T.) in 1966.

produced aquatints depict DNA sequences that could only be seen by late twentieth-century technologies. Inside the book, a poem by Gibson on a diskette reflects on mechanisms of the earlier part of the century and how none were sufficient to capture memories. Ashbaugh's DNA aquatints are overlaid with images of the mechanisms Gibson ponders, such as Polaroid cameras; treated with photosensitive chemicals, the pictures were planned to gradually fade after their first exposure to light. Similarly, playing the diskette would corrupt its programme, after running it only once. The artists were ambivalent in their embrace of our technologically advanced future, as if they foresaw our compulsive need to endlessly and publicly document all our experiences, even though we know this does not forestall loss, forgetting, and death. The work's self-erasure explored destruction as an inevitable part of life; at the same time, in the art world, museums, and libraries, it sparked fierce controversy over notions of permanence in art and literature.[9] Giorgi 'Gago' Gagoshidze and Gianluigi Scarpa have a kindred address of memory and distortion. Their interactive project allows the public to iron poster-printed black-and-white web images and personal photographs onto plastic tablecloths, corrupting the images by sectioning, humble desktop-printing, and melting and stretching. The work deals with recollection and our slippery apprehension of time.

44

While artists have long used digital technology as an image-making tool, some innovators have investigated how the medium itself is transforming our visual experience. Vuk Ćosić, a pioneer of net. art, translates his iconic Linda Lovelace image into ASCII code in all the important media for the history of print: cuneiform, letterpress, and jacquard. He produces a hybrid cuneiform/ASCII object with a 3D printer. Teo Spiller has created the "Laboro", which invents images that correlate to the digital experience: flickering, pixelated, striped. Dragan Ilic also works with machines to explore a new approach to

9 For the most complete information online about this project, see the website "The Agrippa Files: An Online Archive of Agrippa: A Book of the Dead" (http://agrippa.english.ucsb.edu/), maintained by the University of California, Santa Barbara.

mark-making. His "Roboactions" investigate the human-robot gesture and its possibilities for new ways of drawing. Ivan Marušić Klif transfers gesture into image, using the Rutt-Etra effect—a contemporary cousin of the shadow. Combining antique and contemporary tools, he allows visitors to play with their own fleeting skeletal shapes projected by an oscilloscope onto a wall. Sanela Jahić dissects and recombines a scanner and copy machine to create a lightbox-like display that continuously reveals a mysterious egg image, a symbol of the soul. All these artists expand upon the possibilities offered by new technologies to produce new types of imagery in the graphic tradition.

Other artists create their work by drawing on technology's ability to visualise data. Nika Špan is interested in the ways scientific data is pictured. She creates wall-size prints based on charts found on the Internet, which she transforms into visual patterns. Burak Arıkan generates his own diagrams and relational charts to track artistic associations, among other things. His graphs call attention to points of confluence and difference, exposing hierarchies of power. Vargas-Suarez Universal does the bulk of his research about, and through, the American and Russian aerospace industry. Utilising live rover feeds, online data, and technical drawings, his large-scale site-specific wall drawings take the visual elements he has collected through his own study and cross-pollinate them with the local conditions where he is invited to work. Dario Šolman, on the other hand, has been creating his own print and video universe for more than a decade. Combining animation with complex drawn sequences, his artistic language unites science fiction, Japanese anime, and the conventions of museum display, among other worldly and extraordinary concerns.[10]

Other artists survey the world around them, intervening in it, capturing slices of it, and commenting on it with digital tools. Zoran Poposki explores the chaos and beauty of his part-time home, Hong

45

[10] Other recent artists, such as Trevor Paglen, have been interested in otherworldly communication. In November 2012, Paglen launched 100 black-and-white images into orbit from the Baikonur Cosmodrome, Kazakhstan—they were etched onto a wafer-size silicon-and-ceramic disc and enclosed in a gold-plated aluminium container bolted to the side of a communications satellite. Paglen's *The Last Pictures* riffed on astronomer Carl Sagan's *Golden Record*, sent into space on the Voyager 1 and 2 spacecrafts in 1977. Sagan's record, containing various sounds and images, was made of gold-plated copper covered in aluminium and had an electroplated sample of uranium-238 attached to it so that beings of superior intelligence could date it.

Kong, through psychogeographic wanderings. His digital prints conflate the sights and lights he has experienced while mapping the city by intuition. Tammam Azzam, on the other hand, conveys the destruction of his homeland, Syria, by civil war. From safety in Dubai, he painstakingly inserts images of beauty, hope, love, and unity into media images of his crumbling country as a way to cope with loss and exile.

Select artists use digital means to create heretofore impossible images that address conflict and injustice. Luis Camnitzer uses technology to raise 30-year-old questions. Reinserting the names of the Disappeared into a Montevideo phonebook, he asks us to seek them out among the nearly 200 sheets of this quaint and nearly antiquated directory, while questioning if their justice, or our interest, has also become obsolete. Waltraut Tänzler, meanwhile, turns her attention to a timely issue involving questionable practices. Her eerie, printed scenes are stills from live-streaming videos monitoring the US—Mexican border; the videos are found on a website that invites the public to participate in this surveillance. Allora & Calzadilla revisit an artistic theme as established as Goya: the atrocities of war. In contrast to his small-scale drawings, they collect images from casual snapshots published on the Internet by Coalition soldiers in Afghanistan depicting Halloween celebrations on base. Transferred and digitally cut on giant wood plaques placed on the floor of the studio, the ridiculous and terrifying images are printed by hand, as there is no press large enough. Gerhard Richter, the renowned painter, has also staked a strong digital claim. He splits and duplicates the image of one of his own abstract paintings through a computer programme. Dividing it numerous times, he generates thousands of versions, turning the one painting into tiny strips of colour over various prints and artist-book pages, which offer a lush, optical effect.[11]

46

11 Not only Richter, but other contemporary artists traditionally discussed as painters, such as Wade Guyton, are also making new and innovative digital print series.

Some artists interrogate the communication made possible by the Web. Mihael Giba transforms treaties released by the Croatian government into codes that highlight the repetition and obfuscation of their language. In doing so, he translates them from an unreadable legalese to another, equally impenetrable language, underscoring the fact that just because information exists publicly, it is not necessarily legible. Others seek perfect languages for the global village. Yucef Merhi explores the idea of forming words from the things they denote. Moving away from the symbolic realm, Merhi's proposal also has a political twist, where two warring cultures' languages (Hebrew and Arabic) are reflected into one another. Similar and yet different, viewers caught between them must consider their own complicity as they, too, reflect. In the realm of the iconic, Xu Bing transforms his vast collection of international signage, gathered primarily from airports on his extensive travels, into a global chat software that translates natural-language messages into these universal symbols, thereby making basic cross-cultural communication possible.

47

The international dilemmas of communication, as considered through the globe-trotting life of the travelling artist, is summarised in a magnificent, 27-foot-long scroll by Rirkrit Tiravanija. Over three years in the making and combining a variety of both traditional and digital printmaking techniques, the work has as its backbone the pages of Tiravanija's extended passport. Incorporating maps, artwork reproductions, itineraries, recipes, footprints, arrows, and other symbols, it chronicles both the artist's journeys over 20 years and, by extension, his projects. In this way, it also refers to the transformations in the art world over this period, which include the metamorphosis of graphic art in its broad embrace of digital technology.

IV.

Between the two poles of reinvented tradition and newer technologies, we return to Plato and his shadows. A silent drama is playing in Tivoli Park. Captured in hi-res digital images, Charles Juhász-Alvarado (along with his collaborator and model, Karen Albors, and writing partner and translator, Emeshe Juhász-Mininberg) has crafted an animation that toggles between images of sign language-based gestures and poetic

captions. Albors, who has hearing-impaired parents, interprets musical poetry, while the artist's sister, who often translates from Spanish to English, collaborates on the text running beneath. The project alludes to the near impossibility of any kind of real translation. And yet in a fraught world where we rely more and more on international connections and cooperation, this project underscores our dependency on emotional empathy and human commonalities for understanding. The life-size visual sequence unfolds like a flip book as viewers move up or down the path, which leads both into and out of the park. The gestures and rhythms only come to life through audience participation. Walking up and down what artist Marko Pogačnik has recognised as a central energy core of Ljubljana, one tries to understand the music and poetry captured in these shadowy stills. Hands making wings, and the aviary is all around us.

48

The 30th Biennial
of Graphic Arts
Ljubljana:

INTERRUPTION

Allora & Calzadilla

Jennifer Allora, born 1974, Philadelphia, USA
Guillermo Calzadilla, born 1971, Havana, Cuba
Both live and work in San Juan, Puerto Rico;
a collaborative team since 1995

Allora & Calzadilla have collaboratively produced an interdisciplinary body of work that includes sculpture, photography, performance, sound and video. Their artistic practice engages with history and contemporary geopolitical realities in ways that are humorous, poetic, and revelatory.

Recently, they have been working on a series of large-scale, hand-produced woodcuts that explore the relationship between leisure time and wartime. The images are taken from various media images of war in which soldiers enjoy moments of leisure in between combat. The series focuses specifically on US soldiers dressed in costume for Halloween. The concept of an intermission in these works functions on multiple levels: from the military definition (a period when combat action during war temporarily ceases), to its more general meaning (a short interval between acts in theatre). Thus, these works evoke the theatricality embedded in these images of war and allude to some of the most recognised images of wartime debauchery: *The Disasters of War*, created by Spanish artist Francisco de Goya between 1810 and 1815. Finally, intermission is also considered through the medium-specific conditions of woodcut printmaking—namely the transformations of the printed image as a result of printing from a non-uniform, irregular surface. The wood's grain, in effect, interferes with the legibility of the image through the physical and textural markings of the printing process, much as the transmission of these images through analogue or digital means can intervene in them. This visual noise, marked indexically on the surface of the print, creates new dimensions of proximity and distance to these complex documents of war.

50

Intermission (Halloween Afghanistan IV), 2012

Handmade ink print from woodblock template, on linen
Edition of 3 + 1 AP
304.8 x 426.7 cm
Courtesy the artists and Gladstone Gallery

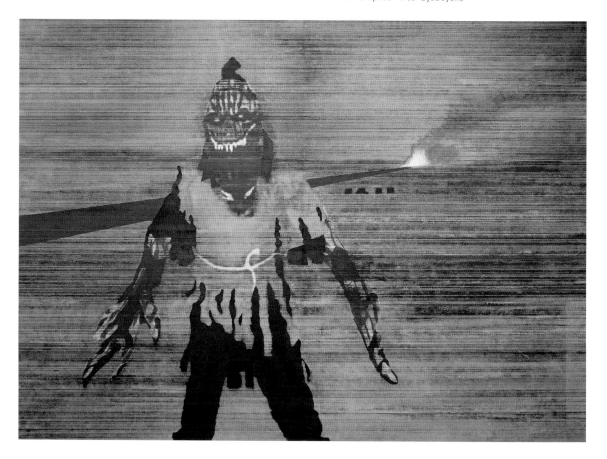

Intermission (Halloween Afghanistan V), 2012

Handmade ink print from woodblock template, on linen
Edition of 3 + 1AP
304.8 x 426.7 cm
Courtesy the artists and Lisson Gallery

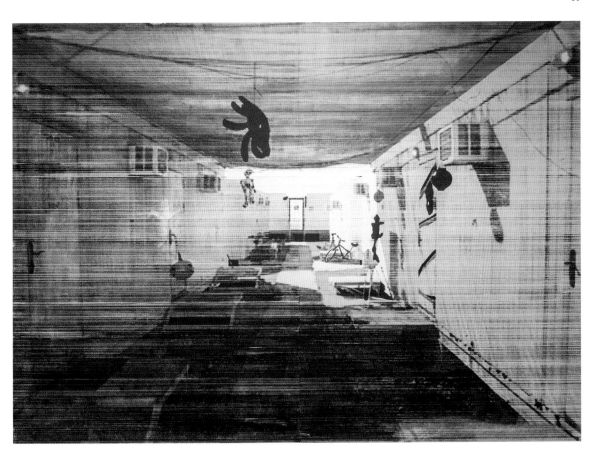

Intermission (Halloween Afghanistan: Interior III), 2013

Handmade ink print from woodblock template, on linen
Edition of 3 + 1AP
304.8 x 426.7 cm
Courtesy the artists and Chantal Crousel Gallery

Burak Arıkan

Born 1976, Istanbul, Turkey
Lives and works in Istanbul and New York

Arıkan works with man-made complex structures and dynamics by applying techniques such as network mapping, network analysis, programming, and protocol authoring. He takes the obvious social, economic, and political issues of the current capitalist society as input. Once run through an abstract machinery, these generate network maps and algorithmic interfaces that make inherent power relationships visible, and therefore discussible. Arıkan is the founder of Graph Commons platform, dedicated to provide 'network intelligence' for everyone. He also conducts network mapping workshops for artists and civil society organisations.

Artist Collector Network is an ongoing data collecting and mapping research project on the 'nature' of the society of art. Each collector is asked to convey a list of artists in their collection. These lists of shared artists connect the collectors on the diagram, which organises itself by running as a software simulation. The names naturally find their position on the screen through connecting forces, revealing the central actors, indirect links, and tight clusters.

Artist Collector Network aims to reveal and question one of the fundamental dynamics of the society of art, the relations of artists and collectors. Arıkan investigates an art world that depends on status, privilege and secrecy by using contemporary technological systems that rely on the principles of free access, open sharing and participation. The first phase of this long-term project is in the permanent collection of the Borusan Contemporary Museum in Perili Köşk. The second phase of the project included collectors and artists affiliated with Maçka Art Gallery. The third phase of the project was presented at the Borusan Contemporary Museum, while this, the fourth phase, which includes collectors from the Balkan region, was created especially for the Ljubljana Biennial.

54

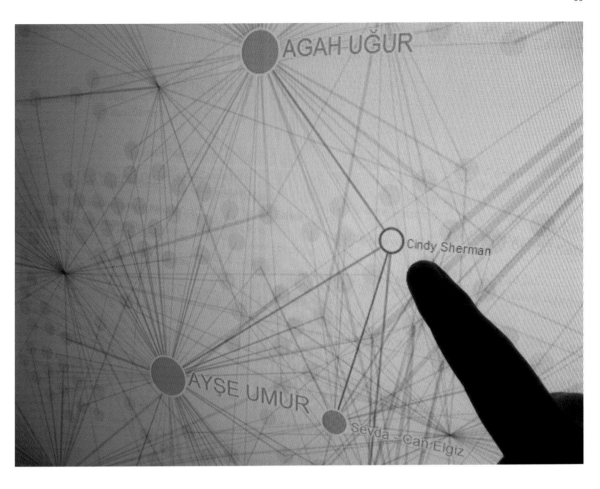

Artist Collector Network: Phase III,
Borusan Contemporary Museum,
Perili Köşk, Istanbul, 2013 (detail)

Data, software, touchscreen monitor
Installation, variable dimensions
Courtesy the artist

Network Map of Artists and Political Inclinations, 2012

Custom software, digital print, mounted on the wall
320 x 525 cm
Installation view, 7th Berlin Biennial
Courtesy the artist

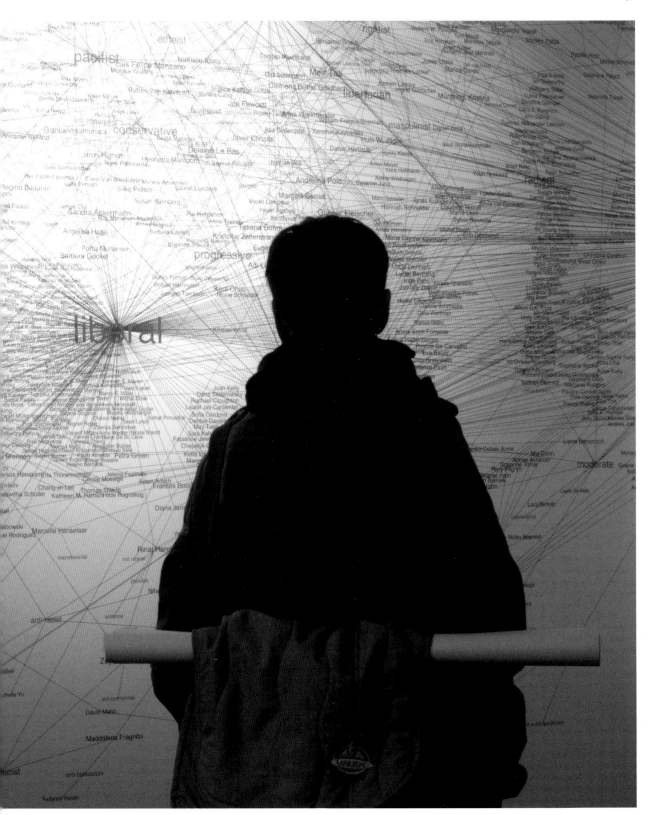

Dennis Ashbaugh and William Gibson

Dennis Ashbaugh, artist
Born 1946, Red Oak, IA, USA
Lives and works in New York

William Ford Gibson, writer
Born 1948, Conway, SC, USA
Lives and works in Vancouver, Canada

Agrippa is a collaborative project that confronts the ethereal nature of memories and the media used to attempt to record them. A case, bound in stained, singed linen, contains intaglios that include excerpts of DNA sequences from the transgenic fruit fly, set in double columns of 42 lines each that refer to the Gutenberg Bible. Treated with photosensitive chemicals, they would gradually fade with exposure to light. The final pages of the book, glued together like a prisoner's hiding place, contain a hollowed-out section for a diskette, on which Gibson's 300-line semi-autobiographical poem was encrypted. An embedded algorithm would corrupt or self-erase upon running. The project was debuted, or 'transmitted', live on the Internet from The Kitchen and The Americas Society, New York, when the poem was read by the illusionist Penn Jillette and performance artist Laurie Anderson. A pirated version spread virally, but the encryption was not hacked for 20 years.

While *Agrippa* appreciated the potential of electronic media, it was also ambivalent towards the technologically advanced future. Both Gibson, who coined the term "cyberspace", and Ashbaugh, one of the first artists to utilise DNA imagery and computer viruses, were attuned to these issues. The poem details objects including a photo album and the camera that took its pictures. The narrator's nostalgia focuses on the motif of 'the mechanism' that transforms subjective experience into allegedly objective representations. Time and geography leave the narrator only with his memories of his hometown and his family, just as the disappearing book would leave its reader only with recollection. The work explores destruction as inevitable parts of a creative, living process. This influential but rarely seen project inspired fierce debate.

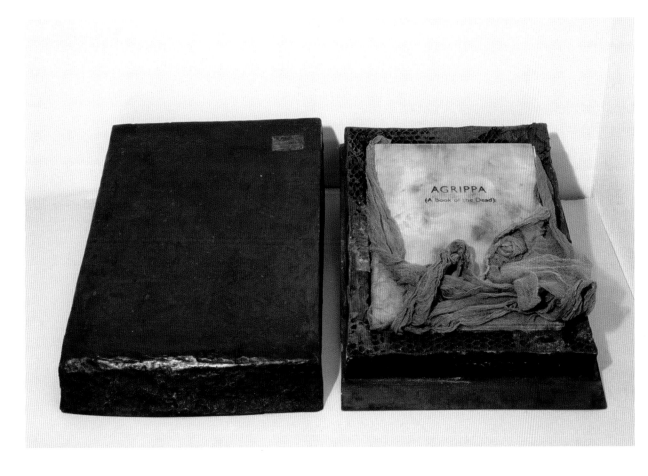

Agrippa: A Book of the Dead, 1992 (deluxe edition)

Copperplate aquatint etchings, printed by Wingate Studios,
treated with photosensitive chemicals, self-encrypted
diskette, metal mesh case sheathed in Kevlar
63 pages
40.6 x 54.6 cm
Courtesy Dennis Ashbaugh

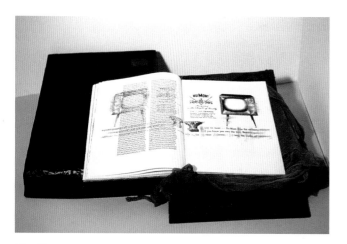

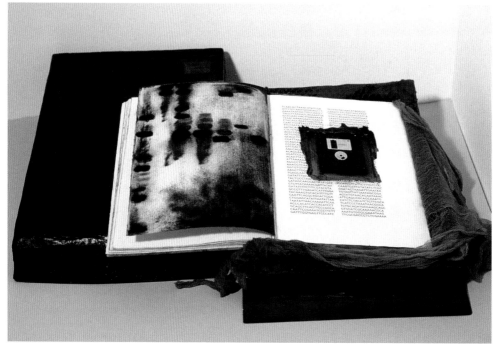

Agrippa: A Book of the Dead, 1992 (deluxe edition)
Various views
Courtesy Dennis Ashbaugh

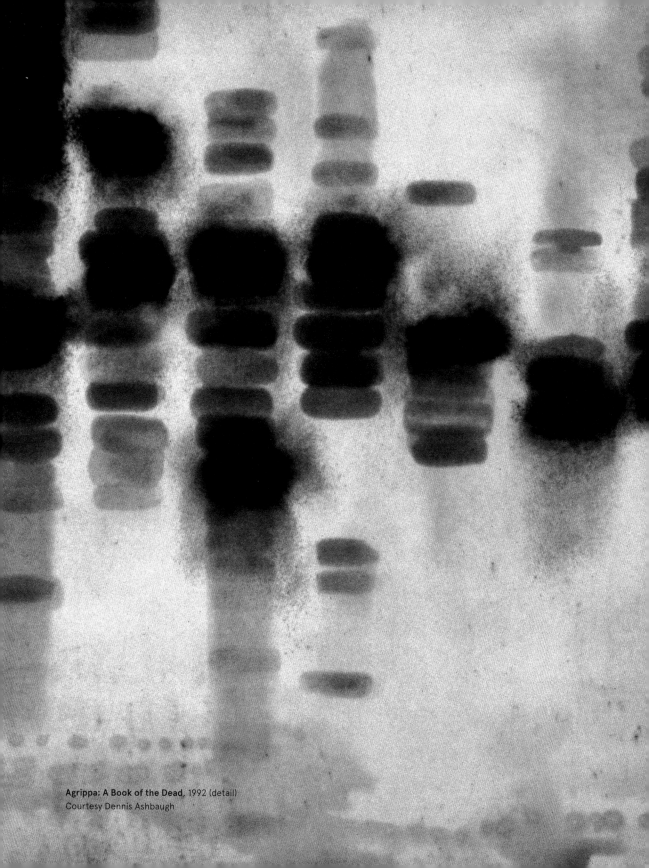

Agrippa: A Book of the Dead, 1992 (detail)
Courtesy Dennis Ashbaugh

Tammam Azzam

Born 1980, Damascus, Syria
Lives and works in Dubai

Azzam began working with digital art after losing his studio in Damascus. He needed new ways to express his sadness about the events unfolding in Syria, his homeland. In his November 2012 solo exhibition held at Ayyam Gallery, Dubai (Al Quoz), digital artworks that represented a location affected by the Syrian Uprising were overlaid with text. The words "In the revolution" were followed by the name of the area that was witnessing the revolution. Other examples took the form of fractured and wounded maps of the artist's country, stop signs covered with bullet holes, bleeding apples, fallen chess pawns and puzzle pieces, and peace signs reconfigured into targets, all symbolising the violence Syrians are facing. For Azzam, the creation of a 'hybrid form' is capable of borrowing and multiplying as it evolves. Recent works have used digital media to examine the ongoing political and social upheaval in Syria and the cycles of violence and destruction that are tearing his country apart.

One work from the *Syrian Museum* series, *Freedom Graffiti,* has gained international popularity on social networking sites. Featured on Saatchi's Facebook page, this work received over 15,000 'likes' overnight and was printed in the *New York Times* and the *International Herald Tribune*. This digital composition appropriates Gustav Klimt's 1907-1908 painting *The Kiss* and projects it upon a bullet-ridden wall. Azzam has juxtaposed this display of love and personal connection with the capacity for hate that a regime can manifest towards its own people.

62

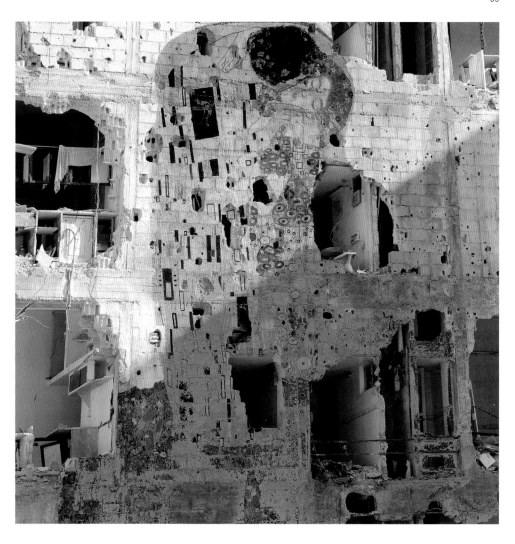

Freedom Graffiti: Gustav Klimt's 'The Kiss', 2013

From the *Syrian Museum* series
Archival digital print on cotton paper
Edition of 25 + 2 AP
112 x 112 cm
The Samawi Collection
Courtesy Ayyam Gallery, Dubai

We'll Stay Here, 2012

Archival digital print on cotton paper
Edition of 5 + 2 AP
112 x 112 cm
The Samawi Collection
Courtesy Ayyam Gallery, Dubai

Conscript, 2012

Archival digital print on cotton paper
Edition of 5 + 2 AP
112 x 112 cm
The Samawi Collection
Courtesy Ayyam Gallery, Dubai

Xu Bing

Born 1955, Chongqing, China
Lives and works in Brooklyn, NY, USA, and Beijing

Xu Bing's ongoing project, *Book from the Ground*, is an ever-expanding repertoire of international icons that recognises the need for an egalitarian, globalised language. Composed of over 25,000 icons or pictograms collected over years, the artist initiated the project during the hours he spent in airports and on planes. In 1999, he began collecting airline safety cards that conveyed information in international symbols.

Book from the Ground is a computer programme that encourages communication between any two people. Two facing but separated computer stations allow one person to type in a message, which is instantly translated into international symbols that the other can read. This instant messaging system stresses the kinds of mediation our communications now go through, and how very close, yet very far, we often are from one another.

Bing himself moved to the United States at age 35. The son of university professors, he was frustrated in his immigration experience as he wrestled with the English language. Recognised for his printmaking and calligraphic skills, Bing often utilised language, words, and text in his installations, questioning how they affect our understanding of the world. While philosophers have long dreamed of a shared language, the need for it has become increasingly apparent. Icon-based computer commands have been priming us to 'read' visual symbols. Bing's work argues that our natural languages have stagnated and are utterly unsuited to the contemporary global village. *Book from the Ground* explores a possible solution.

Book from the Ground

Interactive chat station and software
Installation view at the Museum of Modern Art, New York: *Automatic Update*, 2007
Two computer stations separated by acrylic with printed vinyl
Courtesy Xu Bing Studio

First bound edition of **Book from the Ground**, 2006

Inkjet on paper, hardcover and string bound, with artist's hand corrections and notations in pencil
Courtesy Xu Bing Studio

Luis Camnitzer

Born 1937, Lübeck, Germany; raised in Montevideo, Uruguay
Lives and works in New York

Luis Camnitzer is a conceptual artist, educator and writer who works in a variety of media—including installation, printmaking, drawing, and photography—raising issues of power, representation, and commoditisation, while also questioning the centre and the periphery. Explicitly or implicitly political, Camnitzer often utilises language and text. After moving to New York in 1964, he co-founded the New York Graphic Workshop with artists Liliana Porter and José Guillermo Castillo. This printmaking studio focused on the repetitive, do-it-yourself, and highly disseminatable nature of printmaking.

Memorial replicates the Montevideo telephone directory, in which he has meticulously inserted the names of the Disappeared in Uruguay. During the military dictatorship that ruled the country between 1973 and 1985, nearly 300 Uruguayans were the victims of forced disappearances. Working with lists of names culled from public resources, Camnitzer used digital techniques to create space in the ready-made phonebook and added lines of type, resulting in the reappearance of hundreds of names that are now indistinguishable from the names in the original phonebook. In this way, Camnitzer both references the common listing of names on public memorials while rendering useless the very action of list-making and counting—political or otherwise. At the same time, the work equates target and perpetrator, victim and survivor, prisoner and liberated, in the outdated form of the telephone book, which was meant to facilitate contact in a very different era.

70

Memorial, 2009 (detail)

Pigment prints
Edition of 5 + 1 AP
195 parts, 29.8 x 24.1 cm each
Courtesy Parra and Romero, Madrid
Photograph courtesy Alexander Gray Associates, New York

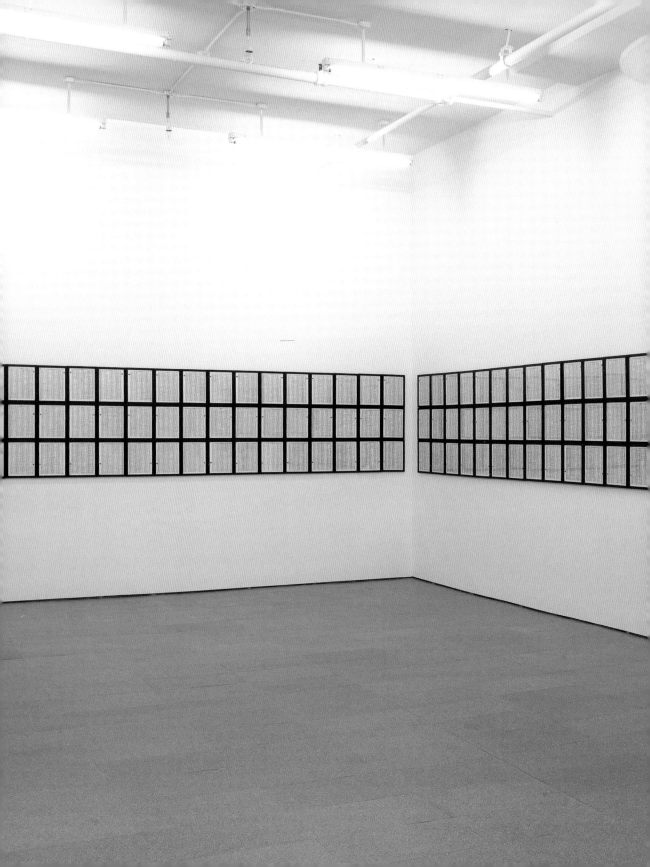

MONTEVIDEO BAL 125

[Telephone directory listing — dense columns of names and numbers reproduced as artwork detail]

Memorial, 2009
(installation view at Alexander Gray Associates, New York, left, and detail, above)
Courtesy Parra and Romero, Madrid
Photograph courtesy Alexander Gray Associates, New York

caraballo-farman

Leonor Caraballo, born 1971, Buenos Aires, Argentina
Abou Farman, born 1966, Tehran, Iran
Both live and work in New York;
a collaborative team since 2001

caraballo-farman's videos, photographs, and installations explore responses, reactions, and public manners. Most recently, they have been working on the series *Object Breast Cancer*, which was inspired by a personal experience with the disease. The artists note that 1.3 million women in the world are diagnosed with breast cancer each year. For most, the tumour has no image. It is an invisible monster, an unseen malignancy. *Object Breast Cancer* is based on the conviction that artistic interventions can have important social and psychological effects. By imaging the cancer, the artists work towards a better understanding. The project includes sculptural and installation work as well as jewellery.

These carcinodaimons fuse three different imaging techniques. A shaman manages to see figures that are said to inhabit human beings using a technique called "extraction", in which the shaman identifies malignant figures and casts them out. An MRI images the breast cancer tumour, identifying its size and location, before the surgeon extracts it. When taken into 3D software, the MRI image of biological matter is translated into an abstract algorithm-based wire-mesh form. Here the wire-mesh forms of breast cancer tumours have been transformed into the figures seen by the shaman during extractions.

74

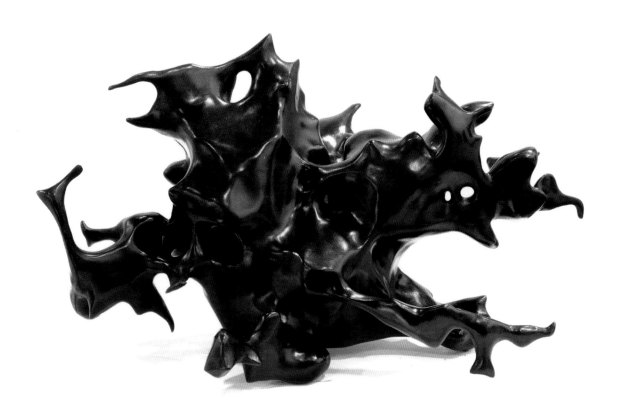

Extractions, 2011

From the *Object Breast Cancer* series
Bronze sculpture
35.56 x 25.4 x 17.78 cm
Courtesy the artists

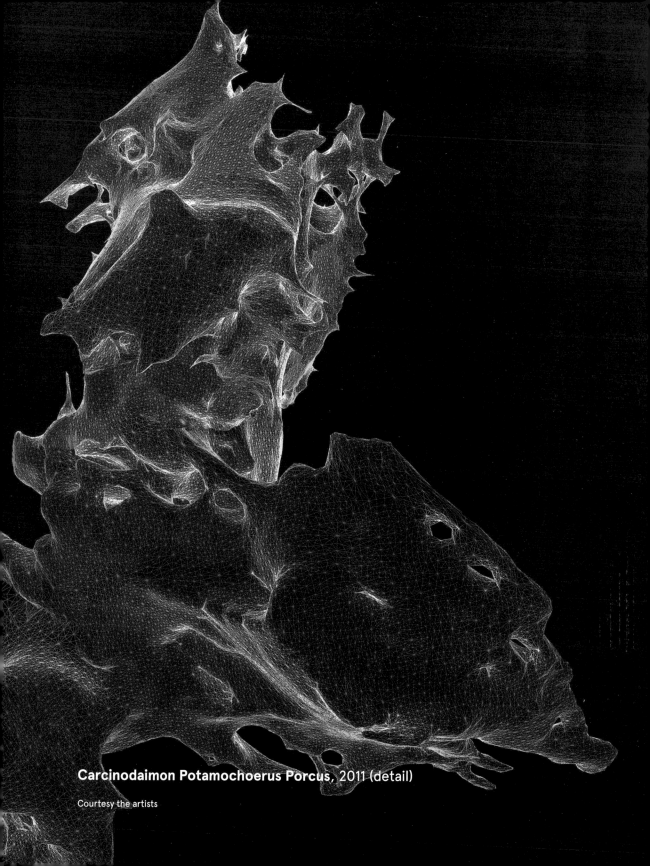

Carcinodaimon Potamochoerus Porcus, 2011 (detail)

Carcinodaimon Potamochoerus Porcus, 2011

From the *Object Breast Cancer* series
UV blockout vinyl print
Photographic prints based on a combination of techniques fusing medical
imaging, 3D modelling and shamanic extractions
101.6 x 127 cm
Courtesy the artists

Alex Cerveny

Born 1963, São Paulo, Brazil
Lives and works in São Paulo, Brazil

Self-taught, Alex Cerveny developed as an artist under the mentorship of his masters. His production does not have a doctrine, law, rule, or routine. His repertoire comes from the sciences, history, art, television, childhood, or daily life. He feels very connected with literature. He is a writer who writes with images.

In this series, Cerveny used *cliché verre*, a process from the late nineteenth century, to illustrate a new version of the 1883 children's novel, *The Adventures of Pinocchio,* written by Italian author Carlo Collodi. In the tale, Pinocchio, created by a woodcarver named Geppetto in a small Italian village, dreamed of becoming a real boy. The story follows his adventures and lessons learned, particularly as he fabricates tales. The technique of *cliché verre* was contemporary to Collodi's text. It consists of scorching a glass plate with a candle, making it opaque with soot, and then drawing on the surface with a sharp object. Cerveny has updated the technique from a chemical to a digital process by finalising the work directly onto the scanner.

The images presented here were originally made for a book published by Cosac Naify. In 2012, the images of the book were collected in a portfolio that also includes additional images repicturing the beloved children's story.

78

As aventuras de Pinóquio, História de um boneco
[Le avventure di Pinocchio, Storia di un burattino /
The Adventures of Pinocchio, The Story of a Puppet], 2011

64 cliché verre prints
Each on 30 x 30 cm paper
Portfolio in an edition of 5
Courtesy the artist
Scanned directly from the plate by Gibo Lab

Chapter 3a
Image, 17.5 x 18 cm

As aventuras de Pinóquio, História de um boneco
[Le avventure di Pinocchio, Storia di un burattino / The
Adventures of Pinocchio, The Story of a Puppet], 2011

Chapter 7 (Top)
Image, 13 x 16.5 cm

Chapter 3b (Bottom)
Image, 13 x 17 cm

Chapter 34 (Opposite)
image 11.5 x 14 cm

Mario Čaušić

Born 1972, Osijek, Croatia
Lives and works in Osijek, Croatia

Miniatures is a series of five precise dry point engravings depicting explosions that took place in different locations and at different times. Čaušić uses the art form of the miniature to stress human resignation and numbness towards the problem of destruction, devastation and killing. Excessive media consumption produces a lack of reaction and empathy to these events. The psychological impact from the quantity of consumed catastrophic images causes this paradoxical reaction, making them seem insignificant and minimal.

In order to create the matrices, the artist utilised techniques most commonly used for making miniatures in the past. He places a magnifying glass by their installation in order to bring observers physically closer to the work. By studying the intricate surfaces of the vast cloud formations at very close range, they might become more aware of their impact. In this way, Čaušić seeks to resensitise them.

82

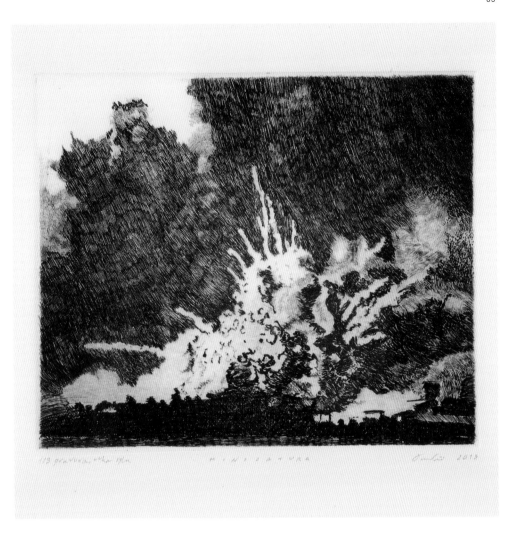

Miniatures, 2013

Engraving, dry point and magnifying glass installation of five prints
Plate 9.8 x 11.8 cm
Each on 35 x 35 cm paper
Courtesy the artist

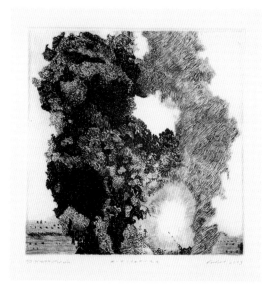

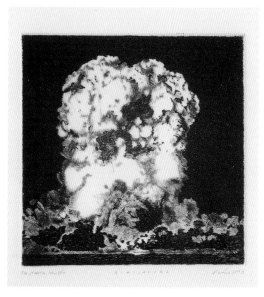

Miniatures, 2013

Plate 11.8 x 10.7 cm (top)
Plate 10.8 x 10.8 cm (bottom)
Plate 11.6 x 8.8 cm (opposite)

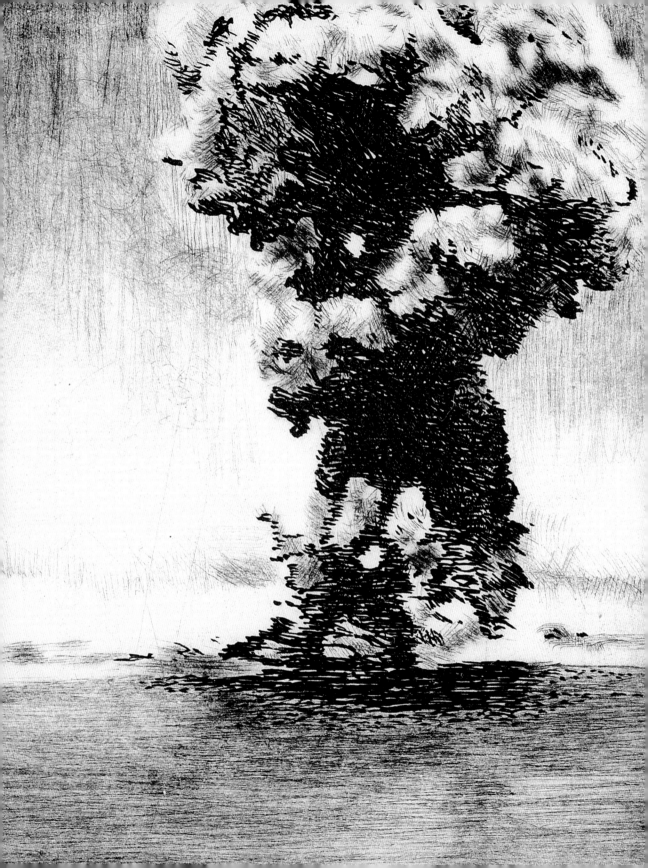

Vuk Ćosić

Born 1966, Belgrade, Serbia
Lives and works in Ljubljana

Active in politics, literature, and art, Ćosić has exhibited and published his creative work since 1994. He is well known for his challenging, pioneering work in the field of net.art. His oeuvre is characterized by a mix of philosophical, political, and conceptual Internet-related issues as well as a feeling for contemporary urban and underground aesthetics. His art touches on the economy, ecology, and archaeology of the media; intersections between text and code; the use of spaces in information; and the digital divide between generations.

Ćosić became interested in ASCII code in 1996. The present work advances his interests in the evolution of communication over long periods of history. The artist has said: "The early Mesopotamian invention of moving images was surely of great significance to early consumers, and *Very Deep ASCII* is an attempt to re-enact that experience, bordering on magic. This particular back-and-forth down Memory Lane consists of cuneiform ASCII, clay, classic porn, and 3D printers. The contemporary viewer is confronted with a one-second movie that took 5,000 years to make."

86

Film still from Deep Throat, 1972 in ASCII code, 1998

Video still

Sumerian cuneiform on clay tablet (summary account of silver for the governor), ca. 2,500 BCE

Shuruppak or Abu Salabikh, Iraq
Courtesy the British Museum, London

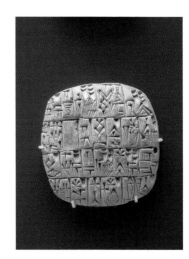

Film still from Deep Throat, 1972

Director Gerard Damiano, actress Linda Lovelace
Gerard Damiano Film Productions (GDFP)

Milos Djordjevic

Born 1978, Ćuprija, Serbia
Lives and works in Zemun, Serbia

Djordjevic, who is currently working on his PhD, has been artistically and intellectually exploring the contemporary limits of graphics. He sees printmaking as a constantly developing process, rather than a medium that serves to repeat a stable form of expression. He experiments with various materials and presentation potentials. By shifting the question from "What is represented?" to "How is it presented?" he deals with 'printmaking as a possibility' and 'printmaking as a potential'. He is interested in the interaction of the work with the space and the observer, and the effect the work can have on the visual and tactile senses. Djordjevic explores interactivity and the possibility of transformation, crossing the line into action, or even performance. Works are conceived as open and variable structures, completed only by the involvement or interference of the author or the audience.

From 2009 to the present, Djordjevic has created interactive, printmaking-based installations such as *Dislocation*. The work is made in an offset printing technique, in a stain manner without a halftone plate. Liberated from the margins and the signature, the print is completely united with the paper. No longer carrying a pictorial element, narrative content is subdued, reduced, simplified, and transformed. Each unit of this basic, modular work is equally important. Mounted on fixed metal rails with magnets, the units can be freely shifted, added to, or removed. Their movement makes a free play of form and shape, implying the transformation and changing states of the work. They incorporate the wall as an active artistic element and contrasting agent. These independent entities, along with the open space they encompass, host a series of ongoing dialogues.

90

Dislocation, 2009

100 flat offset prints in an interactive installation
(kunstdruck paper, magnetic strips, metal rails)
50 x 50 cm each, overall dimensions variable
Installation views of *Modular Prints*, with Ljubomir Vučinić,
Contemporary Gallery, Zrenjanin, Serbia, 2012
Courtesy the artist
Photographs courtesy Marko Subotin

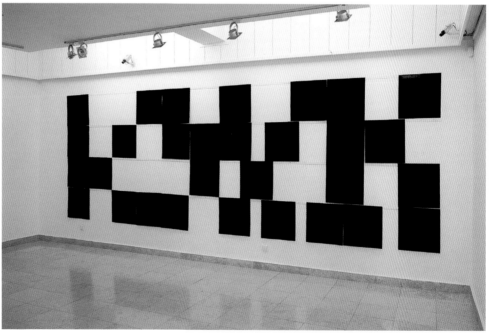

Tomás Espina

Born 1975, Buenos Aires, Argentina
Lives and works in Buenos Aires

Espina is inspired by a wide variety of photojournalistic, media, and art-historical images. He is interested in visions of culture in times of crises or danger. The artist engages what he views as the heirs of dark romanticism, alchemic iconographies, and the experiments of the twentieth-century avant-garde. Through his materials, he transforms them.

Espina initially worked in engraving and traditional graphic techniques. However, he now works with aggressive and unstable media such as gunpowder, soot, and charcoal. He burns, blasts, fractures, and otherwise produces his blasted iconographies. The result is thus residual, a consequence of a corrosive and hazardous action. The artist is interested in violence, and its action works as a determinant. He expects the audience to undergo some awkwardness as they 'reorganise' the information, and he expects the image to behave as a blurry, unhinged presence that provokes reaction.

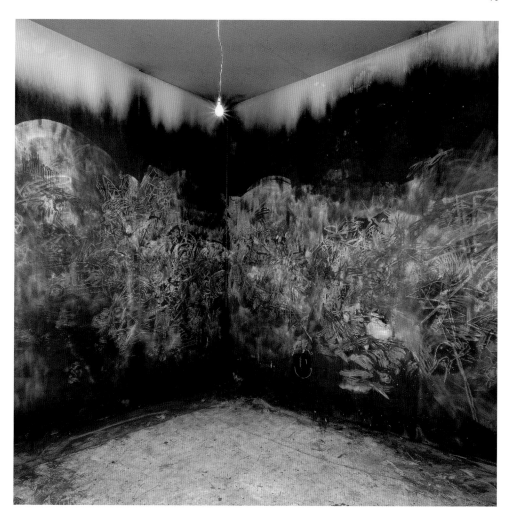

Habitación quemada (la furia de Leúcade)
[Burned room (Leucade's Fury)], 2009

Soot on wall
3.60 x 4 x 4 m
Courtesy the artist and Ignacio Liprandi Arte Contemporáneo, Buenos Aires

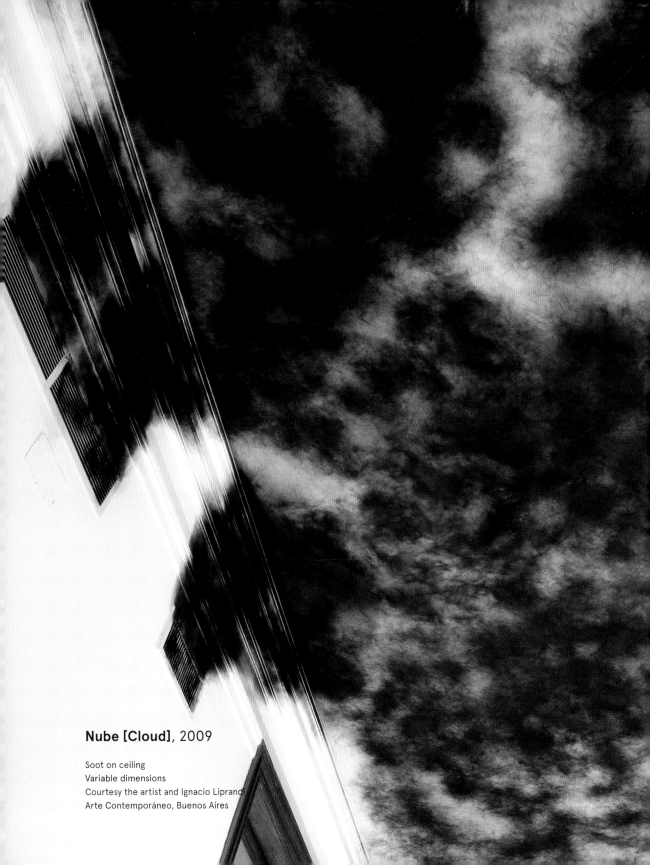

Nube [Cloud], 2009

Soot on ceiling
Variable dimensions
Courtesy the artist and Ignacio Liprandi
Arte Contemporáneo, Buenos Aires

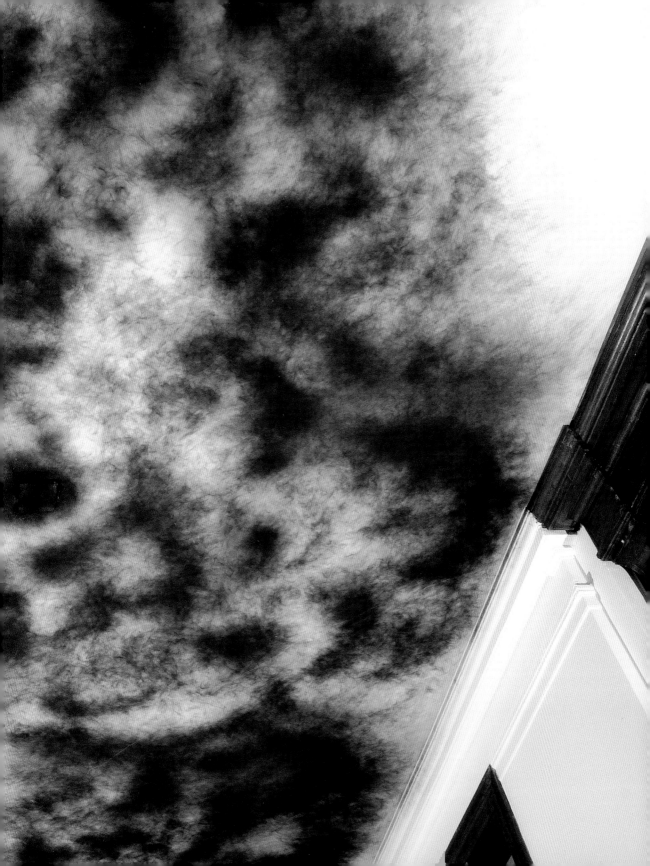

Giorgi Gago Gagoshidze and Gianluigi Scarpa

Giorgi Gago Gagoshidze
Born 1983, Kutaisi, Georgia
Lives and works in Berlin

Gianluigi Scarpa
Born 1991, Treviso, Italy
Lives and works in Europe

Gago and Scarpa, reflecting on the state of fluctuation in which we live, have produced the collaborative project and ongoing series, *About Heat and Numbers*. They have written that, today, neither the geopolitical landscape nor the technological panorama seems stable: we live in a state of constant updating, immersed between the numbers running inside our computers. Thus, their project has both a media and archaeological focus, and is centred on an old electric iron, an easily transported tool that can be charged with memories, an intimate monument. Through heat, the iron can transfer images from sources ranging from personal archives, magazines, and the Internet to a wide array of supports. The resulting prints are always somehow deteriorated. In the end, the iron becomes the only stable point in this process of translation.

The artists' engagement with the iron is, therefore, performative: they have to figure out the relation between the standards of the world around them and the measurement of their inner perceptions through the movement of imperfect images from one surface to another.

98

About Heat and Numbers, 2013

Iron print
66 x 46 cm
Courtesy the artists

About Heat and Numbers, 2013

Iron print
140 x 200 cm
Courtesy the artists

Mihael Giba

Born 1985, Varaždin, Croatia
Lives and works in Zagreb

Giba's work combines scientific and artistic methods to point out everyday events that affect society. His art focuses on data visualisation, and he develops special computer software that serves as its basis, mapping both individual and global social phenomena and repeating statistical patterns. He is interested in how information is designing our lives.

Trust me I trust you is a project that was created in response to the major corruption scandals that have affected the Croatian government and led to the arrest of the now-prime minister and several highly positioned politicians and ministers. This work deals with the trust that citizens have given to politicians. The project consists of five legal documents from the Croatian government that Giba has transformed into an artistic language and presented as five books.

The books contain different treaties that the Croatian government had long refused to publish. Giba has visually translated the now-available texts to highlight the difficulty that average citizens have in reading these legal and economic documents. For example, in the Accession Treaty, he colour-codes the word "Croatia" in red, white, and blue and the words "European Union" in blue and yellow, leaving them in the positions where they are located on the original treaty page while deleting all other text. In other contracts, he highlights the number of times characters repeat in one row. Through this visualisations, Giba raises the question of whether the citizens, who give their trust to people who must represent them in matters that concern everyone, have the knowledge they need to control the politicians, or if they simply trust them.

Trust Me I Trust You, 2012

Digital print
Five books
210 x 297 mm each
Courtesy the artist

Croatia–EU Accession Treaty

INA and MOL Shareholders Agreement
(above and top opposite)

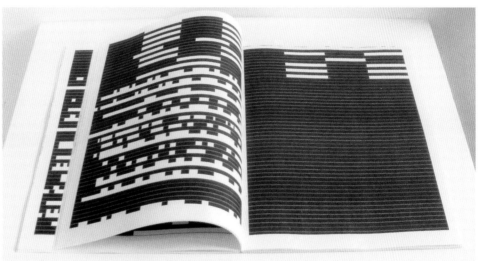

Croatian Privatisation Fund and
Orco Property Group S.A.—Suncani
Hvar Shareholders Agreement
(bottom)

Ana Golici

Born 1955, Balaci, Romania
Lives and works in New York

Ana Golici`s interest in nature attracted her to the Scanning Electron Microscope (SEM) at the New York Hall of Science in Queens, NY, where for several years she studied different insects in depth. *The Biggest Flea on Earth* was composed of 200 SEM images representing the entire body of a flea enlarged 750 times. On the screen of the SEM, at that magnification, the artist could only view one section at a time. To figure out where she was while exploring the body of the flea, and to be sure to photograph it from the same angle, Golici created a temporary map. The surface of the flea proved to be the most unexpected territory. The artist discovered it piece by piece, with no idea of what she would see next. She took Polaroid shots of each image she discovered and then moved on to the next section.

Slowly and cautiously, Golici mapped the unknown territory. The original images were black-and-white Polaroids, but she also kept negatives. In 1995, at Hunter College in New York, she was able for the first time to put the entire flea together. It was a huge, 900 x 700 cm collage of photo-static prints. Later, as digital technology evolved, she could integrate all the flea images together in a better, more seamless way than was previously possible. The image of the flea has continued to appear in Golici's works in different formats. This recent production is a glass-etched flea, which was made in 2009 during a residency at the Corning Museum of Glass in Corning, NY.

The flea is one of the most despised insects on earth. But seen at this size, it commands our respect. Golici states that when we look at it we will always see ourselves reflected in it.

The Biggest Flea on Earth, 1993–2009

Edition 1 of 3
118 sandblasted glass rectangles, 18 x 23 cm each
Final size: 370 x 300 cm
Collection of the artist
Photograph by Nicolae Golici

The Biggest Flea on Earth, 1993–2009 (detail)
Photograph by Nicolae Golici

The Biggest Flea on Earth, 1993–2009 (detail)
Photograph by Nicolae Golici

María Elena González

Born 1957, Havana, Cuba
Lives and works in New York and Basel, Switzerland

González's interests in various disciplines and media have contributed to her wide-ranging body of sculptural work. She combines materials, tactilities, and often viewer interaction. Death and loss, memory and impermanence, dislocation, identity, celebration, and anxiety are all themes explored in her work; the wonder of nature features prominently.

Best known for sculptural installations that are architecturally as well as personally informed, one of González's most recent series, *Tree Talk*, was inspired by her encounter with a fallen birch tree in the woods of the summer artist colony at the Skowhegan School of Painting and Sculpture in Maine. She collected and flattened its bark, made drawings and rubbings, and then scanned its striated patterns to see what kind of sounds would result. She digitally translated the bark patterns and had them laser-cut into a roll for a player piano. When played, the scroll has an unexpected 'score': the phrasing, polyphony, and rhythms seem deliberately composed and modern. This project allows us to hear the 'music' of the birch tree and reminds us of the inherent logic that exists in all of nature's patterns.

110

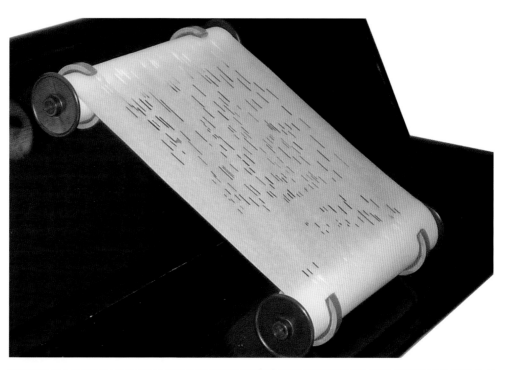

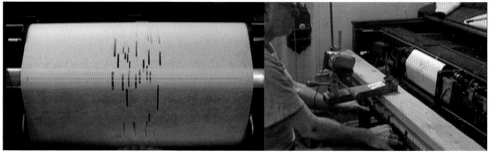

Tree Talk Series

Skowhegan Birch #1, 2012

Piano Player Roll (top)
Edition 2 of 4
30.5 x 5.1 cm dia.
Courtesy the artist

Video (bottom)
6:14 min
Video still
Courtesy the artist

Untitled, 2012

Birch bark, Sharpie, ink, cardboard, tape
86.4 x 100.3 cm
Courtesy the artist

Birch Rubbing #3, 2012 (detail)

Graphite, laser and ink jet on vellum, on Japanese paper
130.8 x 114.3 cm
Courtesy the artist

Meta Grgurevič and Urša Vidic

Meta Grgurevič, born 1979, Ljubljana, Slovenia
Urša Vidic, born 1978, Kranj, Slovenia
Both live and work in Ljubljana;
a collaborative team since 2009

The collaborative and complex installation projects of Meta Grgurevič and Urša Vidic are based on a multimedia vocabulary that explores the boundaries between stage and gallery installations. They cross-pollinate the specific codes and signs of both the art space and the theatre, breaking the boundaries between them. Moving between history and memory with deliberate playfulness and wonder, their mechanised environments, replete with cast shadows, take us into a stream of consciousness, at the edge of narration.

One of their most recent projects, *Galanterie Mécanique/Fil d'argent* [*Mechanical Galanterie/Silver Thread*], was a symphony of kinetic objects, video, performance and music that contemplated the relationship between man and machine, collaboration and cooperation between individuals, and the position of the individual within wider social relationships. The work referenced both Charlie Chaplin's critique of modernity as expressed in the 1936 film *Modern Times* and its embrace in the Russian theatre system of Vsevolod Meyerhold. These anxieties and enthusiasms continue to be reflected in the new industrial age, in which everyone has to do their part in order for the functioning system to continue as a complex, living organism.

The project can be described as a dance performance in which the human performer is replaced by objects that display basic mechanical principles, moving to a musical composition and reacting to light. All the elements, including objects, music, and lights, are tightly interconnected and mutually reactive. This creates the atmosphere of a ballet.

114

Galanterie Mécanique/Fil d'argent
[Mechanical Galanterie/Silver Thread], 2013

Drawing on paper and digital processing
28 x 21 cm
Related to the variable-size installation with shadows, sound, and kinetic
objects made of wood, Plexiglas, lamps, and electric motors
Co-produced by Lighting Guerilla
Music and performance by Left Finger and Bowrain
Previously presented at Škuc Gallery, Ljubljana
Courtesy the artists

Galanterie Mécanique/Fil d'argent
[Mechanical Galanterie/Silver Thread], 2013

Drawings on paper and digital processing
28 x 21 cm each
Courtesy the artists

Galanterie Mécanique [Mechanical Galanterie], 2013

Video still
Courtesy the artists

Dragan Ilic

Born 1948, Belgrade, Serbia
Lives and works in New York and Belgrade

Drawing on a long-standing interest in physics and mathematics, Ilic explores the interaction between the creative mind and robotic activity. He has invented numerous mark-making devices and has used over 300,000 pencils, crayons, markers, paintbrushes, and lasers, on paper, canvas, or metal placed directly on the ground.

In 1974, Ilic began to explore the inherent role devices play in the drawing process. Through this collaboration between the human and the machine, he began to create large-scale multiple-line abstract drawings. His work now aims to provide a context for dialogue between the artist and the viewer through technology, a context he believes to be specific to the twenty-first century. What started as groups of 15 pencils controlled by his hand has transformed into 900 pencils manipulated by a combination of computer and robotic technologies. This allows him to create outside both the boundaries of his own physical being and the traditional boundaries between the artist and the viewer, whom he hopes to immerse in the process. Through the interaction between the artist and viewers, Ilic creates a new kind of work, with viewers as equal participants in a 'visual democracy' that is supported by the emerging technologies of today.

118

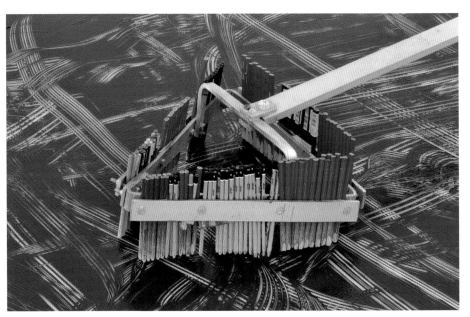

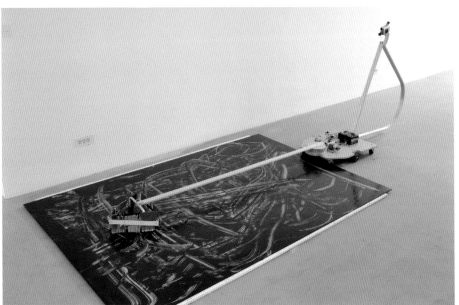

Roboaction 8, 2010

Interactive, site-specific drawing, remote-controlled electric machine,
aluminium, felt pen, pencils, and gravity over one hour
Installation view at ID Space, New York
Courtesy the artist

Roboaction 8, 2010 (detail)

Courtesy the artist

Sanela Jahić

Born 1980, Kranj, Slovenia
Lives and works in Škofja Loka, Slovenia

Jahić's work explores and subverts the classical concept, format, and notion of painting, and investigates the image as both a message and a surface. Moving paintings with machine frameworks or production mechanisms controlled by computer programs, produce moving light and sound projections or dematerialised pictures: illusions that are fleeting, fragile, and ephemeral in nature. This machine–image dialectic reflects on the status of the social subject in the contemporary technologised world, as well as the individual's inclusion in disciplinary regimes, ideological apparatuses, patriarchal authority, and dogmatic principles. The artist is interested in subjectivity as the juncture of inscribed, regulative discourses, while the phantasm is constitutive of reality.

Jahić's first lumino-kinetic object, *Dogma II*, presents the beginning of these explorations. An optical reader/scanner mechanism gradually unveils a mystical image on Plexiglas. A chain transmission motor, taken from an old copy machine, moves the neon light up and down, illuminating a screen print framed above and below by hands. In the centre, a found still from Alan Parker's film *Angel Heart*, 1987, reveals the Devil's hands peeling an egg: "You know, some religions think that the egg is the symbol of the soul." Another quote from the film is also relevant: "They say there's just enough religion in the world to make men hate one another but not enough to make them love."

122

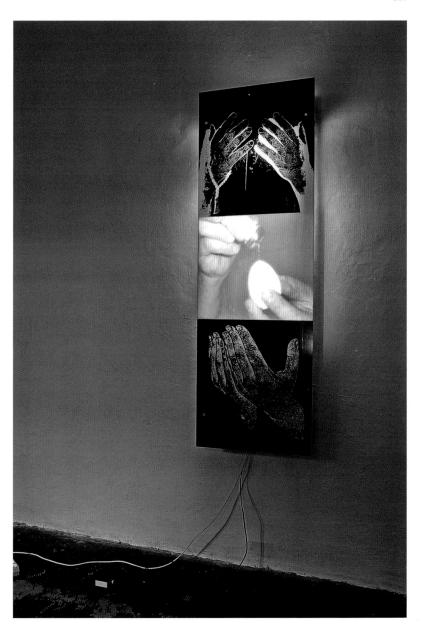

Dogma II, 2004–2005

Machine
161 x 55 x 20 cm
Courtesy the artist
Photograph courtesy Janez Pelko

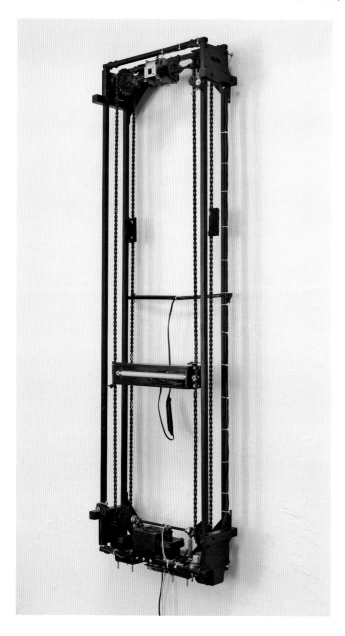

Dogma II, 2004–2005 (mechanism)
Photograph courtesy Toni Mlakar

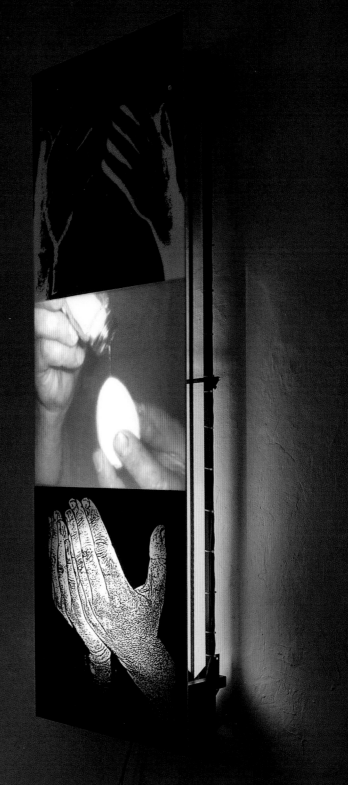

Dogma II, 2004–2005
Photograph courtesy Janez Pelko

Charles Juhász-Alvarado

Born 1965, Clark Air Force Base, Philippines
Lives and works in San Juan, Puerto Rico

Trained in sculpture and architecture, Juhász-Alvarado's elaborate projects are inspired by history and current events. His ambitious undertakings contain sound, narrative, collaborative contributions, and participatory and site-specific experiences. Recent outdoor installations incorporate percussion; a commission for a rural site includes handmade wooden Xylophones as sculptural bridge banisters that can be played by entering and exiting visitors.

In a related idea, the artist composes a 'melody' in four movements for the 118 posters lining the Jakopič Promenade in Tivoli Park. Flanking the benches, the images mirror or rhyme to act as a choir. Working with Karen Albors, whose parents are both hearing-impaired, he created a visual sequence that unfolds as viewers walk up or down the esplanade. The artist's sister, Emeshe Juhász-Mininberg, a writer and translator (working in Spanish and English), collaborated on the 'lyrics' related to each image that build the 'song'. These allude to the images but also weave a cadence to accompany viewers on the path. The Slovene version and design by Mina Fina are yet another partnership, emphasising the counterpoint of languages while foregrounding translation, chance, and exchange. The project depends on universal commonalities to elicit emotional understanding.

Perhaps this project also refers to Zoltán Kodály (1882–1967), a Hungarian composer and educator whose influential teaching methodology improved upon hand signs invented by English minister and music teacher, John Curwen. Curwen developed his gestural system for sight-reading and musical notation, convinced that music should be accessible to all people. (In Steven Spielberg's 1977 film *Close Encounters of the Third Kind*, Curwen's hand signs are even used to communicate with aliens.) Juhász-Alvarado, who has incorporated images from both Puerto Rico and Ljubljana in his backgrounds, similarly fosters meeting, communication, exploration, and exchange.

126

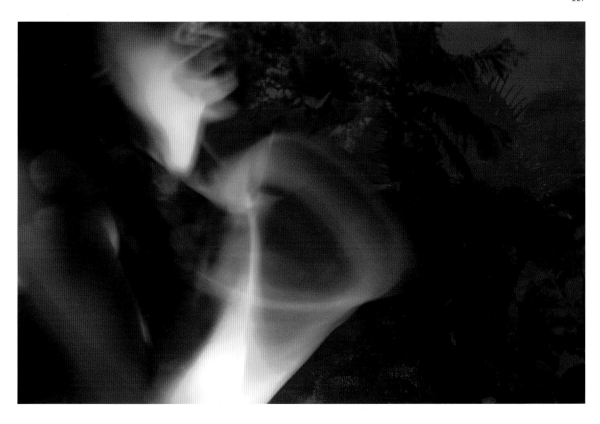

Entre Manos (From Hand to Hand): Cipher, Knot, Nebula, 2013

118 digital photographs for public poster commission
Jakopič Promenade, Tivoli Park, Ljubljana
185 x 125 cm each
Courtesy the artist

In collaboration with
Emeshe Juhász-Mininberg
Born 1964, Clark Air Force Base, Philippines
Lives and works in Brookline, MA, USA, and San Juan, Puerto Rico
and
Mina Fina
Born 1978, Ljubljana
Lives and works in Ljubljana

With studio assistance in San Juan by: Cesar Acosta,
Karen Albors, Teo Freytes, and Ana Rosa Rivera

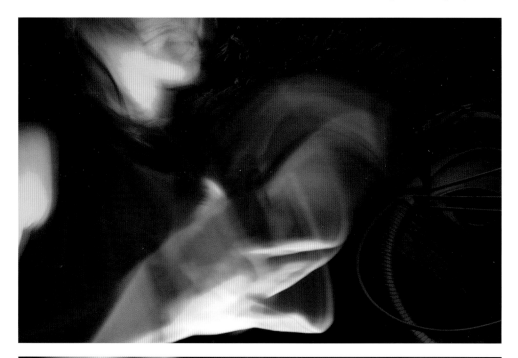

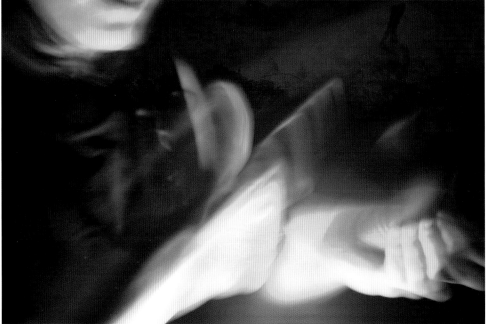

Thomas Kilpper

Born 1956, Stuttgart, West Germany
Lives and works in Berlin

Kilpper is internationally renowned for his use of architectural-scale woodcuts that transform historical buildings and spaces. He engages the past as well as the public sphere by revealing hidden or obscured political and social stories. His literal and metaphorical excavation, beyond official lines, works for justice. The artist conceives his projects as installation or performance works that develop a large-scale visibility and provoke public dialogue. With many of his print projects, his carving *in situ* is a model of literal resistance: Kilpper works with teams of assistants, using heavy tools to coax images from wooden floors, then printing them at full scale to be mounted publicly. His work expands political dialogue, not only to include previously excluded voices but also to integrate these stories into an international history of resistance.

130

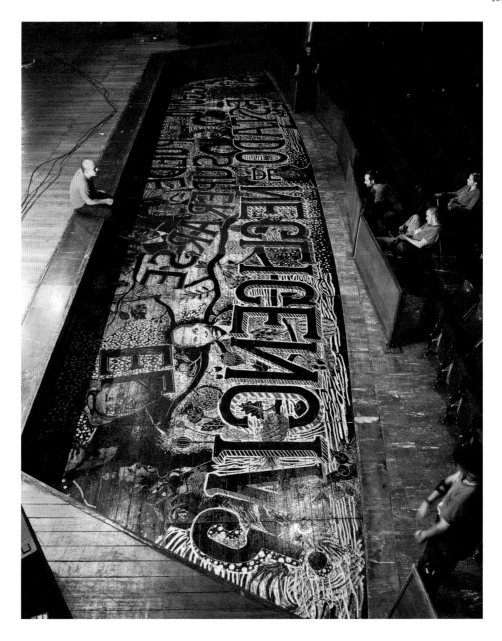

**¿Cómo puede superarse el estado de negligencia?
[How to Overcome the State of Neglect?]**, 2011

Floor-cut, orchestra pit of Teatro Pablo Tobon Uribe, Medellín, Colombia
In conjunction with Encuentro Internacional de Medellín (MDE11)
Courtesy the artist

State of Control, 2009

Floor cut and printing project in cooperation with Neuer Berliner Kunstverein, n.b.k.
Canteen in the former Ministry for State Security of the German Democratic Republic (East Germany)
Courtesy the artist and Galerie Christine König, Wien and Patrick Heide Contemporary, London
Photo courtesy Jens Ziehe, n.b.k.

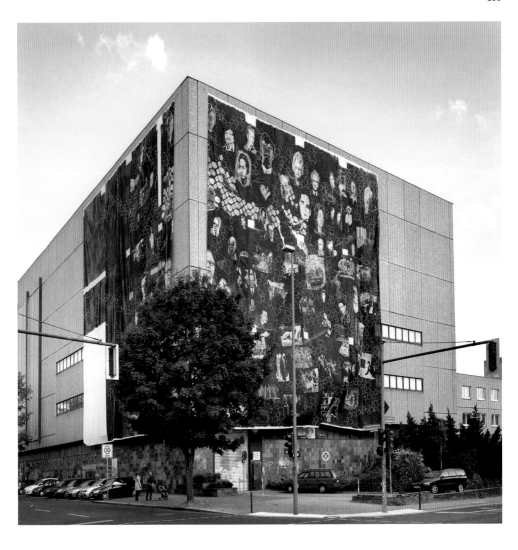

State of Control, 2009

Entire print hanging at the facade during the exhibition
Floor cut and printing project in cooperation with Neuer Berliner Kunstverein, n.b.k.
Courtesy the artist and Galerie Nagel Draxler, Berlin, Cologne
Photo courtesy Jens Ziehe, n.b.k.

André Komatsu

Born 1978, São Paulo, Brazil
Lives and works in São Paulo

Construção de Valores is an installation that uses tall columns of photocopies. The sheets contain words selected from the dictionary and images from online newspapers. The 14 definitions consider the concepts of power, progress, system, control, language, structure, word, territory, base, state, discipline, security, order, and trust. The 12 images are random impressions that depict oil, a school, a crowd, a building, a bum, time, the police, TV, a podium, a crash, a block, a farm. At the centre is a pile of blank paper. Each stack is placed in a perpendicular position. Thus, a paper-block construction forms a hierarchical construction of these values. Four industrial fans are placed so that their air stream crosses the blocks. The movement of the wind destabilises the construction, promoting a reorganisation of values and recomposing the sheets into a horizontal base.

134

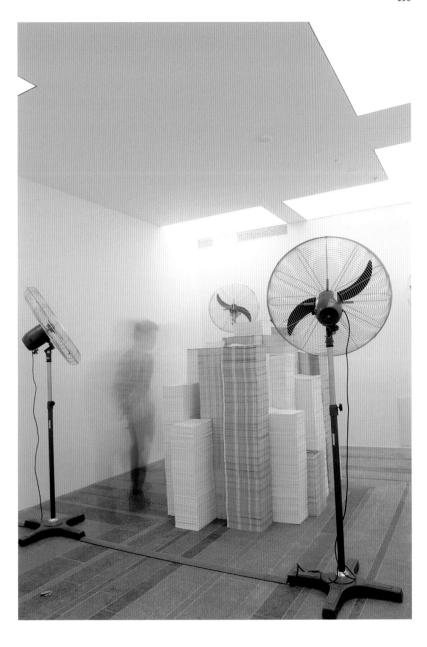

Construção de Valores [Constructing Value], 2012

Installation with A4 photocopies and industrial fans
Variable dimensions
Installation view, *Future Generation Art Prize*, 2012, Pinchuk Art Centre, Kiev
Courtesy the artist

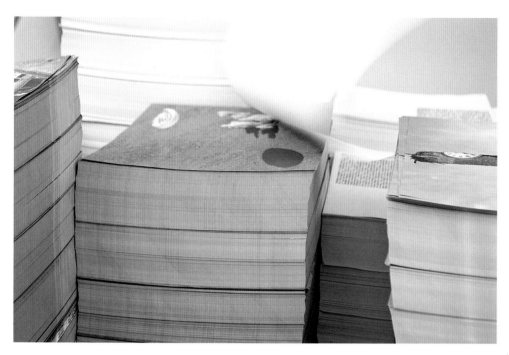

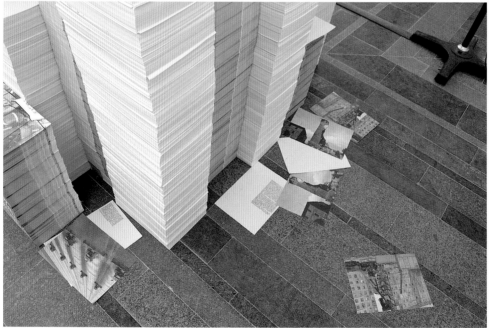

Construção de Valores [Constructing Value], 2012
Installation view, Future Generation Art Prize, 2012, Pinchuk Art Centre, Kiev
Courtesy the artist

Gorazd Krnc

Born 1973, Ljubljana, Slovenia
Lives and works in Ljubljana

Book of Numbers with Old Masters' Reproductions is a unique volume made on recycled metal offset printing plates. It contains 27 leaves, or bound plates, on which reproductions of Old Master paintings are printed and coloured, as well as texts by Petja Grafenauer and Zoran Srdić Janežič. The reproduced images are taken from the collection of Wilhelm Weicher of Leipzig, published between 1906 and 1912.

This is the first of four books in a tetralogy (the others are *Video Book of Numbers*, *Audio Book of Numbers*, and *Sand Book of Numbers*). In each book, 27 numbers are depicted; altogether there are 108 images of numbers in various forms. Krnc chose the number 108 because it could be said to represent the ultimate truth of the universe, as it displays in itself (paradoxically) unity, nothingness, and infinity. Also, the result of the equation *2 sin (108°/2) = ϕ* is the golden ratio.

Krnc has noted that numbers seem cold and metal plates seem hot, and this relationship interested him. Metal, from its basic form (as iron ore or waste iron) to the end product (in this case, thin plates), goes through extreme thermal processes and metaphysically retains great heat. Numbers are abstract, impersonal, cold, and also universal. An interpretation of numbers is emotive, emotional, and personal. To the many existing interpretations of numbers he adds his own absurd perspective through Old Master pictures. While there may not be any real connection, the artist is creating a new graphic interpretation.

138

Knjiga števil št. 1: Knjiga števil z mojstrskimi reprodukcijami [Book of Numbers No. 1: Book of Numbers with Old Masters' Reproductions], 2012

Recycled metal offset plates
600 x 758 cm
Courtesy the artist
Installation photographs by Sunčan Stone, Alkatraz Gallery, Ljubljana, 2012

31

DIE HOFDAMEN
(*Madrid, Prado*)
D. Anderson, Photo.

**Knjiga števil št. 1: Knjiga števil z mojstrskimi reprodukcijami
[Book of Numbers No. 1: Book of Numbers with Old Masters'
Reproductions]**, 2012 (selected pages)

Photographs by Sunčan Stone

6

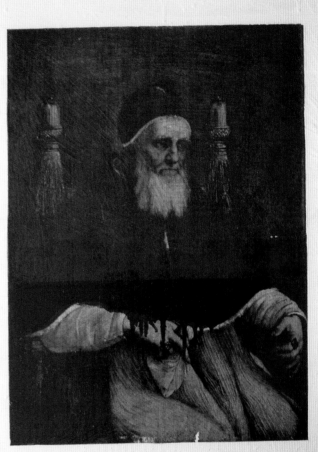

BILDNIS JULIUS II. IN EINEM
STUHLE SITZEND
(*Nationalgalerie, London*)
F. Hanfstaengl

Volodymyr Kuznetsov

Born 1976, Lutsk, Ukraine
Lives and works in Kiev

In his original version of this project, Kuznetsov—who is trained in textiles and often works with embroidery—reflected upon Ukrainian independence from the Soviet Union in 1991. He traced patterns from elements of Ukrainian folk embroidery onto a 1990s BMW and perforated it by having it shot with various firearms. BMW cars were associated with the aggressive mafia wars and violent power struggles that emerged during the transformation of the region, and thus he had it decorated by the method of its destruction. After Ukraine became independent, Kuznetsov remarks, it adopted a new folk-tradition course in its cultural politics.

For Ljubljana, Kuznetsov will consider the typical Balkan VIP car: status symbols such as the VW Golf, Audi, and Mercedes—the cars in the region that are most frequently stolen. They were brought from abroad to show wealth and power, and it was this type of car that was used by the first Slovene government in the early 1990s. These models are associated with an arms scandal from that period. During the separation of Yugoslavia and the conflicts of the early 1990s, a group of high-level Slovene politicians, military experts, Special Forces soldiers, army police, and others were linked to the illegal arms trade, selling guns and ammunition to Croatia and Bosnia. The scandal has since reached into Austria and Finland. In Slovenia, the investigation of this issue is an ongoing and open wound, and Kuznetsov's car alludes to this as well.

142

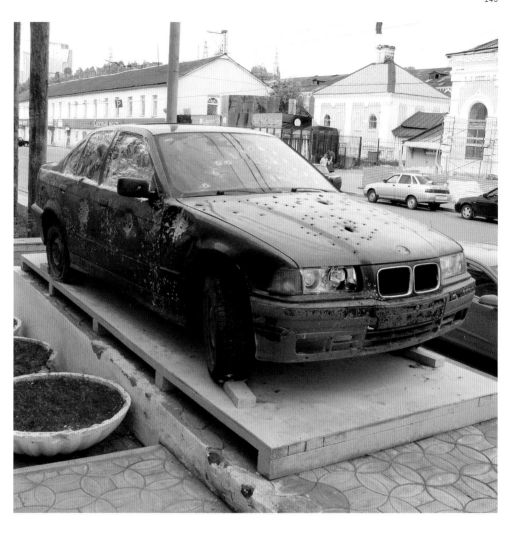

VIP Car, Monument to the '90s, 2010

Object, video documentation
Variable dimensions
Installation, Perm Museum of Contemporary Art (PERMM), Perm, Russia, 2010
Courtesy the artist

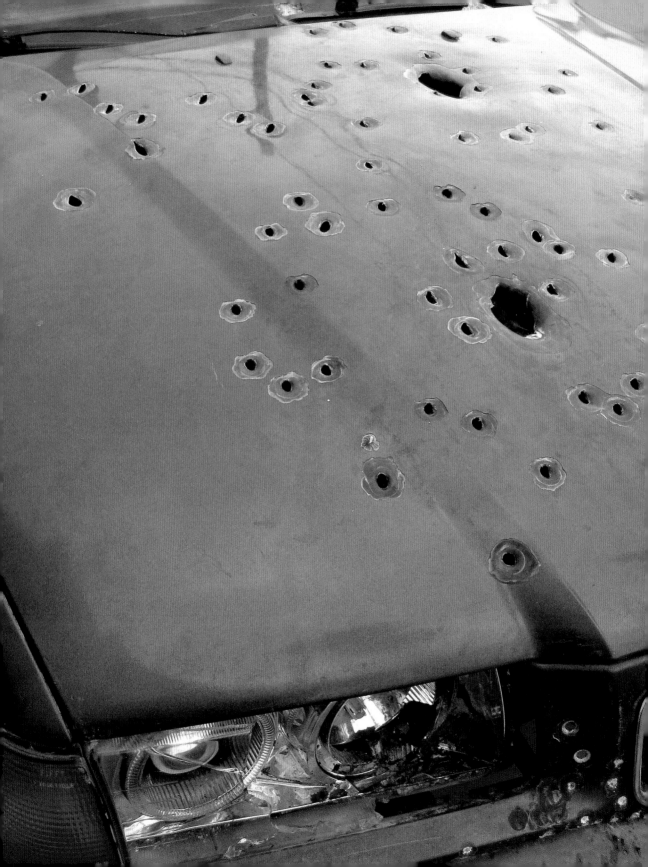

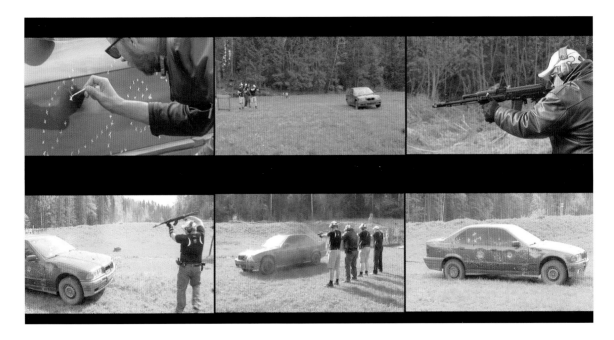

VIP Car, Monument to the '90s, 2010

Video stills
Installation, Perm Museum of Contemporary Art (PERMM), Perm, Russia, 2010
Courtesy the artist

Nicola López

Born 1975, Santa Fe, NM, USA
Lives and works in Brooklyn, NY, USA

López's work incorporates signs of mobility, speed, communication, growth and technology characteristic of society today. She maps the contemporary landscape experientially, with wonder and vertigo. Accretions of imagery and physical material reflect layers of architecture, history, technology, and topography. For her, intaglio, woodblock, and drawing are closely linked to the artist's hand, even as they refer to automation and mass production. The tension between order and disorder creates images that struggle against themselves, striving towards beauty as they verge on the edge of spinning beyond control or comprehension.

This work depicts the possibly endless cycle of the formation and destruction of an urban mass. Through stop-frame animation, López utilises printed elements and tape to create a landscape that achieves the pinnacle of construction and then is unmade. As it disintegrates, it leaves a blank space where the next 'city' rises and falls.

146

In its reference to a tower that grows as high as the heavens before being destroyed, *The Babel Cycle* alludes to the Biblical Tower of Babel. The cyclical narrative evokes building blocks, and includes printed images of familiar landmarks such as Mesoamerican pyramids, the Eiffel Tower, and a building from Fritz Lang's *Metropolis*. It also recalls the child's game in which a tower of sticks is stacked as high as it will go until the last piece topples the structure. Beyond this playful front lies a sharper edge, critical of a society that is bent on building itself ever larger and ever faster—even at the risk of losing stability and becoming physically unsustainable.

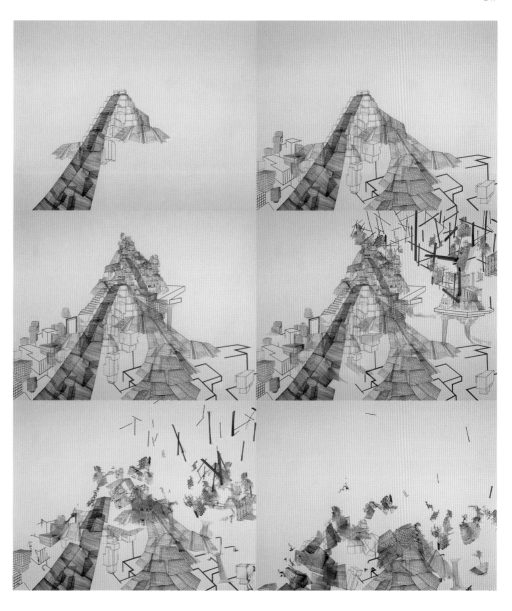

The Babel Cycle, 2013

Six stills from single-channel digital stop-frame animation using
silkscreen-printed elements and blue tape
Projection size 182.9 x 274.3 cm
Courtesy the artist

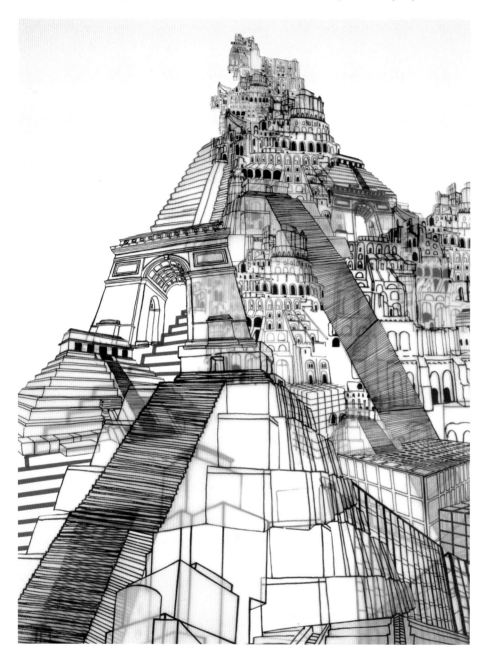

The Babel Cycle, 2013 (details)
Courtesy the artist

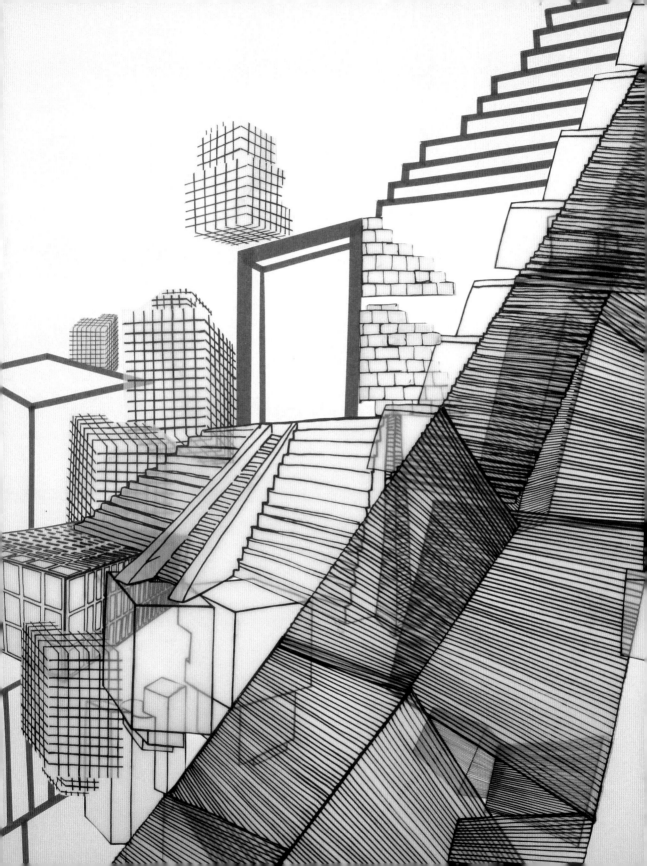

Ivan Marušić Klif

Born 1969, Zagreb, Croatia
Lives and works in Zagreb

Klif is a multimedia artist whose work includes light, kinetics, music, sound, and performance art. In this project, he utilises vector rescanning, also known as scan processing or the Rutt-Etra effect. Named after two video engineers that refined the technique in the late 1960s, it is an old video-processing technique. Scan processing typically requires equipment that is both extremely rare and expensive.

Klif invented a way to recreate the technique with an ordinary computer. As in the original process, the image from an analogue video camera is processed, tweaked, and finally redrawn on an analogue oscilloscope. Occurring now within the computer, this is a cheaper and much more flexible method than the original one, but the resulting image has a lower scan resolution. By connecting his system with Kinect, a new and innovative 3D scanner made for the Microsoft X-Box (typically used in games for motion tracking, but also in art and DIY projects), he was able to display the contemporary 3D sensor on the analogue oscilloscope. He felt this was a perfect match of antique and contemporary tools, and presented it first in an AV performance with the musician Petar Dundov in Zagreb in late 2012.

Klif's work consists of two adjoining video projections in the corner of a darkened room. In the middle of the space is a small 'nest' of equipment. In its idle state, the projections are black. Once a visitor approaches, the installation wakes up. Kinect provides a 3D scan of the space, but it also gives a real-time 3D 'skeleton' of the person. Movements of the head, hands, and legs become parameters in the video synth. The installation is dynamic, visual, and poetic. It has to do with texture, signals, and waves, and creates what the audience sees as a magical, rather than technical, work.

150

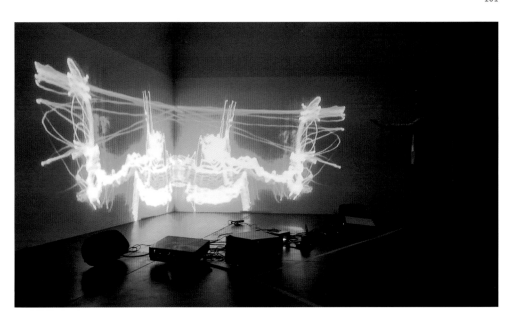

Untitled, 2013

Multimedia interactive installation, with two video projections, two full-range loudspeakers, and computer
Dimensions variable
Installation view, *T-HT nagrada*, Museum of Contemporary Art, Zagreb, 2013
Courtesy the artist

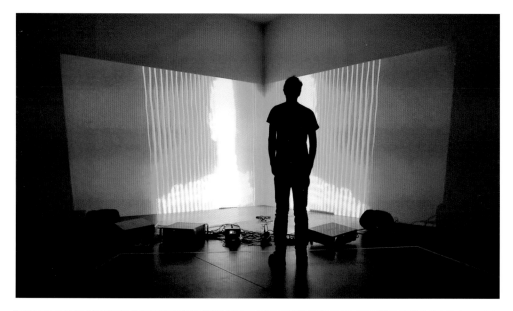

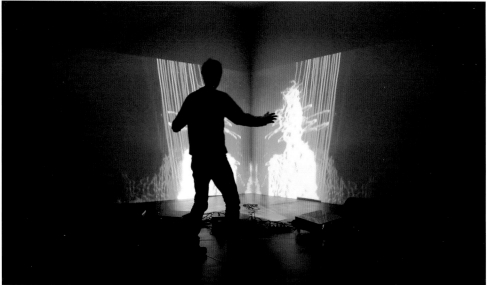

Untitled, 2013
Courtesy the artist

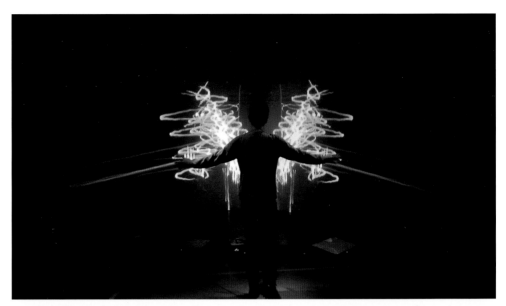

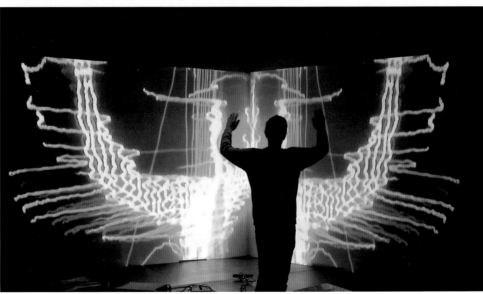

Yucef Merhi

Born 1977, Caracas, Venezuela
Lives and works in New York

What do Plato, Dante, Guillaume Postel, Raymond Lull, Giovanni Pico della Mirandola, Nicholas of Cusa, Giordano Bruno, Giulio Camillo, Athanasius Kircher, John Wilkins, Francis Lodwick, Leibniz, Giacomo Leopardi, Ludwik Zamenhof, Bertrand Russell, Ludwig Wittgenstein, Noam Chomsky, and Pierre Lévy have in common? They were all interested in (or obsessed with) finding a perfect language.

While many thinkers have argued about the possible existence of a perfect language, few have tried to find it. After examining different models and explanations, Merhi came to the conclusion that a perfect language cannot be made out of words; it must be composed of common physical elements that can be recognised by any civilisation from any place and any time. Two historical figures were crucial to his research: Jonathan Swift and Ferdinand de Saussure. Both thinkers indicated that the way to build a perfect language was to employ the objects certain words denote. Thus, a perfect language functions as a meta-language, and not as a natural or formal language.

Here, *Perfect Language* (מראה-مرآة) is composed of custom-cut mirrors that configure the word "mirror" in both Arabic and Hebrew. The words are placed facing each other, reflecting their own content as well as any passers-by.

154

Perfect Language (מראה-مرآة), 2013

Proposal drawing for custom-made mirrors
Variable dimensions
Courtesy the artist

Perfect Language (Light), 2010-2012

Seven projectors, computers, custom software
Variable dimensions
Courtesy the artist

Perfect Language (못), 2012

1000 nails
100 x 100 x 10 cm
Courtesy the artist
Photos courtesy Tirone García

Ottjörg AC

Born 1958, Heidelberg, Germany
Lives and works in Berlin and Porto Alegre, Brazil

The incisions made by 12- to 16-year-old boys and girls on school desks express sensitivities, love messages, the names of music bands, and political statements. Everywhere in the world where adolescents are socialised and disciplined by schools, these carved signs—regardless of their maker's nationality, gender, or social class—communicate the boredom of the school routine, the desire for self-assertion, and emerging sexuality.

A specially developed intaglio printing technique exposes these signs to our eyes, and a poetic composition unfolds on soft textured paper the same size as the original desk. The *Deskxistence* project reflects, like a palimpsest, varying temporalities and multiple levels of content. Personal messages and social references are scratched into desk surfaces and then taken up by the generations that follow. Some desks testify to natural catastrophes or changes in the political system. The pupil disregards the school's prohibition in order to leave a physical mark. A field of tension is created between the local event and global universality, and *Deskxistence* makes this palpable.

The project raises issues around youth and education, urban life, social classes, temporality, language and sign language, as well as straightforward artistic themes. So far, it comprises 600 works on paper, made from the school desks of 48 schools on five continents. These include works from schools in Guangzhou (China), Vienna, Sarajevo, Skopje, Istanbul, Beirut, Ramallah (Palestine), Haifa (Israel), Jerusalem, and Cairo, all in 2007; 11 schools in different districts of São Paulo and three in Zhong Shan (China), in 2008; nine schools in different districts of New York City, in 2009; schools in Zhu Hai (China) and Mosbach and Mundingen (Germany), in 2010; and nine schools in different districts of Berlin, in 2011.

158

Aha-Skopje (top)

From the *Deskxistence* project, 2007–2011
Intaglio print on vat paper
55 x 125 cm
Courtesy the artist

Beirut II, Lebanon (bottom)

From the *Deskxistence* project, 2007–2011
Intaglio print on vat paper
62.23 x 76.20 cm
Courtesy the artist

Face of Istanbul

From the *Deskxistence* project, 2007–2011
Intaglio print on vat paper
52 x 125 cm
Staatliche Museen Preussischer Kulturbesitz, Kupferstich Kabinett Berlin
Courtesy the artist

Renata Papišta

Born 1981, Sarajevo, Bosnia and Herzegovina
Lives and works in Sarajevo

Papišta, who works in the Department of Printmaking at the Academy of Fine Arts in Sarajevo, is engaged with experimental graphics. She is interested in the state of the graphic arts today and the importance of change and new methods of implementation in the field. She seeks to combine classic techniques with innovative physical solutions. She has worked with transparent X-rays and installation objects, as well as site-specific wall works related to printed collage. The artist generates both connections and confrontations with the traditional arts. While she is inspired by the sites where she is invited to work, her projects are linked to the human condition and often balance forms and themes involving dichotomies such as fullness/emptiness or presence/absence.

E.A., 2012

Woodcut, unique site-specific work
210 x 25 cm
Gallery Collegium Artisticum, Sarajevo
Courtesy the artist

Fragment, 2010

Woodcut, unique site-specific work
26 x 30 cm
Academy of Fine Arts, Sarajevo
Courtesy the artist

BH Grafika, 2011

Woodcut, unique site-specific work
120 x 120 cm
Gallery Collegium Artisticum, Sarajevo
Courtesy the artist

Adam Pendleton

Born 1984, Richmond, VA, USA
Lives and works in Germantown, NY, and New York

Adam Pendleton is a visual artist, writer, avid reader, and performer, whose projects are multidisciplinary hybrids. He utilises appropriation, reference, and quotation, most frequently Xeroxing and then silkscreening image fragments and text from a wide range of international historical and cultural sources to create new, anonymously granular vistas. Pendleton is interested in the qualities of copy toner and has noted that the Xerox machine is the most indispensable tool in his studio. His work is generally made up of composite sections, as well as open or mirrored spaces, often produced in a serial format. His imagery recontextualises the elements he includes through his in-depth and wide-ranging research; he is extremely interested in publications and book reproductions. Through repetition and interruption, Pendleton addresses the future while talking about the past. His work mixes and matches elements in an almost advertising-like graphic language to create new and politicised frameworks.

Larry Hinton (white), 2012

Silkscreen ink on Formica
Overall installation, variable dimensions
304.8 x 61 cm, four panels, each unique
Courtesy the artist and Pace Gallery, New York

Untitled (Woman I), 2013

Silkscreen ink on Mylar, headless stainless steel pins
289.5 x 221 cm, overall installation
96.5 x 73.6 cm, nine panels, each unique
Courtesy the artist and Galeria Pedro Cera, Lisbon

Untitled (Woman II), 2013

silkscreen ink on Mylar, headless stainless steel pins
289.5 x 221 cm, overall installation
96.5 x 73.6 cm, nine panels, each unique
Courtesy the artist and Pace Gallery, New York

Agnieszka Polska

Born 1985, Lublin, Poland
Lives and works in Warsaw

Agnieszka Polska creates videos with primarily found materials, such as archival photography and illustrations. Subjecting them to subtle interventions, including animation and collage, the artist changes their primary context, while creating the illusion of documentation. Her visually powerful explorations of lost times or half-forgotten figures from the Polish avant-garde reflect on the way the past is fictionalised and reworked. Her animated videos evoke a longing for something that perhaps never was but which she makes real on film. Her work has a slow, unnaturally calm pace that gives it a meditative quality. Many of her videos are only a few minutes long, whittling down images and emotions to a concise dosage, while in numerous cases also referencing 1960s conceptual art.

Polska's most recent work includes scripted dialogue and actors. In her new film, *Future Days*, Polska describes the future as a space deprived of every attribute but memory. She stages a 'heaven for artists' that is both ludicrous and melancholic: in a symbolic, phantasmal landscape, artists from different generations meet after death and engage in discussions that explore such questions as human desire, knowledge, metaphysics, and the sublime.

170

With the support of the Culture
Programme of the European Union.

Future Days, 2013

HD video still
20 min
Courtesy the artist

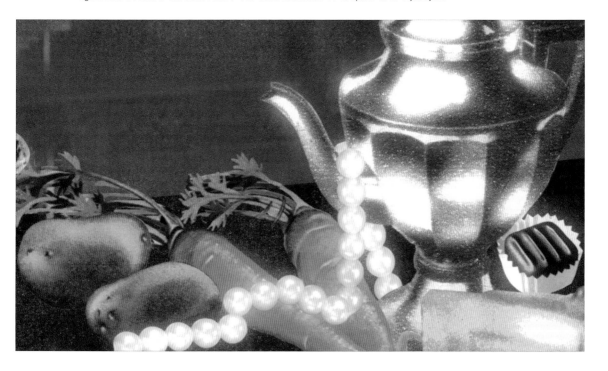

Plunderer's Dream, 2011

HD video stills
3:56 min
Courtesy the artist

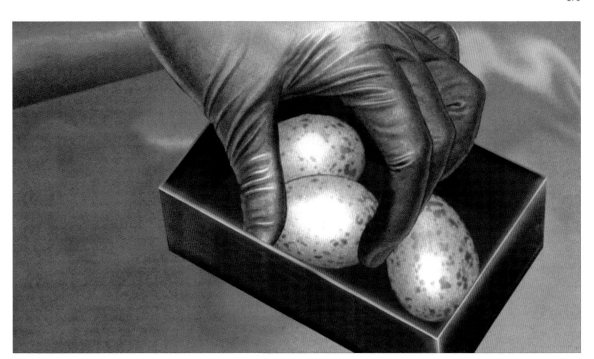

Zoran Poposki

Born 1974, Skopje, Macedonia
Lives and works in Skopje and Hong Kong

Poposki's print series was inspired by Dung Kai-cheung's novel *Atlas: The Archaeology of an Imaginary City*, a work of (postmodern) fiction about Hong Kong. The artist traced the locations in the book onto the real terrain of today's Hong Kong by means of "psychogeography", a practice in which the urban environment is explored based on play, curiosity, wonder, and chance. The sites are documented in digital photographs, and then again transcoded into visual form as a print. Poposki explores the mechanisms governing the intersemiotic translation of the urban landscape. He considers the emerging centreless chronotope of global negotiation and interchange between different cultures. His project is about positionality and a sense of place, about cultural translation and transcoding. *Hong Kong Atlas* mediates between different cultural flows.

174

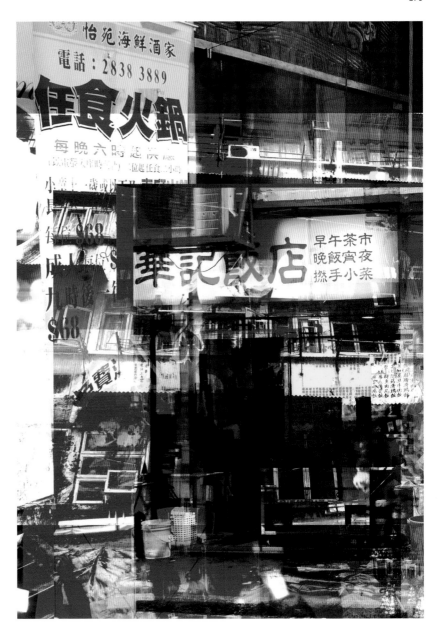

Hong Kong Atlas 1, 2012–2013

archival pigment print on canvas and screen-printed acrylic paint
125 x 90 x 5 cm
Courtesy the artist

Hong Kong Atlas 2, 2012–2013

Archival pigment print on canvas and screen-printed acrylic paint
125 x 85 x 5 cm
Courtesy the artist

Hong Kong Atlas 3, 2012–2013

Archival pigment print on canvas and screen-printed acrylic
125 x 85 x 5 cm
Courtesy the artist

Marjetica Potrč

Born 1953, Ljubljana, Slovenia
Lives and works in Berlin

Tirana—Designs for a New Citizenship is based on Potrč's research in the Western Balkans during the *Lost Highway Expedition* in 2006. The work reflects on the remaking of the public space in Tirana, Albania, after the political changes of the 1990s. This period was characterised by the city's unprecedented growth. The rapid construction of an informal city by ordinary citizens converged with a project by Tirana Mayor Edi Rama to paint the facades of apartment blocks. The two efforts created an unparalleled cityscape. The painted buildings along Tirana's main avenues function in two ways: the designs deconstruct the modernist architecture beneath them, while the language of pattern is employed in a unique performance that expresses a new citizenship—a new social contract—for a city in transition. *Tirana—Designs for a New Citizenship* presents a large wallpaper overlaid with drawings and prints. It is part of a greater body of work that draws on Potrč's on-site research projects.

178

 Lost Highway Expedition (LHE), 2006, was a research journey through nine cities in the Western Balkans (Ljubljana, Zagreb, Novi Sad, Belgrade, Skopje, Prishtina, Tirana, Podgorica, and Sarajevo). This was a self-organised trip supported by a core group of artists and architects (including Potrč) with additional support by individuals and cultural institutions from the visited cities. More than 300 artists and architects took part. LHE reflected on the remaking of society in the former Yugoslavia and Albania. For Potrč, the most interesting aspect of the trip was reading the society's new values in its architecture.

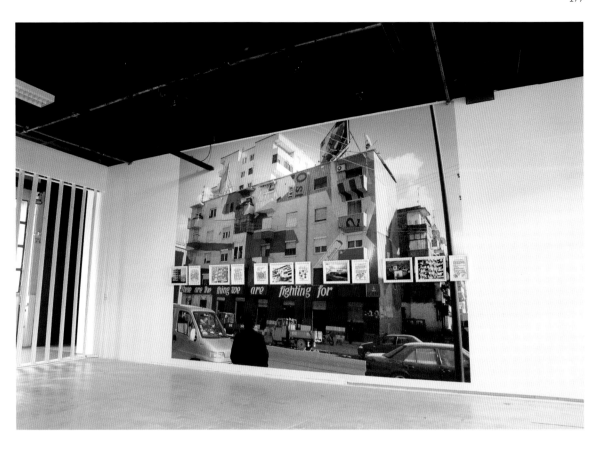

Tirana—Designs for a New Citizenship, 2009

Based on research from the *Lost Highway Expedition*, 2006
Wallpaper with six ink-jet prints and six drawings
Overall installation, variable dimensions
Courtesy the artist and Galerie Nordenhake, Berlin/Stockholm
First exhibited at *Europe XXL*, Lille 3000, Lille, France, curated by Elena Sorokina

▬A RITE OF TRANSITION ▬

THE MODERN ERA HAS PASSED.
NOW IT'S TIME TO PAINT WILD PATTERNS
ON THE BUILDINGS ALONG THE CITY'S
AVENUES.

EDI RAMA

IN A PROJECT INITIATED BY MAYOR
EDI RAMA AND SUPPORTED BY CITIZENS
IN A REFERENDUM, THE PAINTED
FAÇADES WORK TWO WAYS:
1. THE DESIGNS DECONSTRUCT WHAT'S
BENEATH THEM – THE MODERNIST
ARCHITECTURE.
2. AS AUTONOMOUS SURFACES, THEY
EXPRESS A NEW CITIZENSHIP (= A NEW
SOCIAL CONTRACT) FOR A CITY IN
TRANSITION.

PATTERN IS A LIVING LANGUAGE!

Tirana—Designs for a New Citizenship, 2009 (detail)
Drawing No. 2/6
Ink on paper
29.7 x 21 cm
Courtesy the artist and Galerie Nordenhake, Berlin/Stockholm

◼ PATTERN IS AN ORGAN ◼

PATTERN IS A LIVING SURFACE —
THE SKIN OF A BUILDING,
ITS SHIELD.
PATTERN PROTECTS!

EDI RAMA:
"FAÇADES ARE NOT LIKE A DRESS OR
A LIPSTICK. THEY ARE ORGANS."

Tirana—Designs for a New Citizenship, 2009 (detail)
Drawing No. 3/6
Ink on paper
29.7 x 21 cm
Courtesy the artist and Galerie Nordenhake, Berlin/Stockholm

Gerhard Richter

Born 1932, Dresden, Germany
Lives and works in Cologne, Germany

Since the early 1960s, Gerhard Richter, one of the world's best-known contemporary artists, has simultaneously produced abstract and photorealistic painted works, as well as photographic and glass pieces. He has created hundreds of dragged and blurred colour abstract compositions. Interested in traditional painting as well as mass-media imagery, the artist projects found photographs onto canvas, then blurs the paint with a soft brush or squeegee.

Richter's most recent project, *Strip Paintings,* are actually unique large-scale digital prints. Their imagery consists of narrow, horizontal striations, all generated from variations of one of his own works, *Abstract Painting 724-4*, 1990. At age 80, Richter has plunged into digital production. He utilised a software programme, while following a complex set of self-imposed rules, to break down his composition into 8,190 horizontal striations arrived at through 12 stages of division. Each strip is then mirrored and repeated, printed out, sliced, rearranged manually, and rephotographed. The mirroring, recombination, and repetition alludes to games of chance as well as algorithmic processes. Due to the unusual optics and scale of these fields of thin coloured bands, the works themselves offer a vibrant and vibrating visual effect that refers to digital space while also commenting on the obsessions of modernist art.

Richter's 2011 editioned artist's book (as well as the trade version) documents a selection of the patterns, printed over double pages, of the more than 4,000 versions he created and from which he selected to make his large-scale *Strip Paintings*.

182

925–4 STRIP, 2012

Unique digital print mounted between Aludibond and Perspex (Diasec) in three parts
300 x 300 cm
© Gerhard Richter, 2013
Special thanks to Marian Goodman Gallery, New York

924–1 STRIP, 2012

Unique digital print mounted between Aludibond and Perspex (Diasec) in four parts
200 x 600 cm
© Gerhard Richter, 2013
Special thanks to Marian Goodman Gallery, New York

Venelin Shurelov

Born 1977, Burgas, Bulgaria
Lives and works in Sofia

The artwork *Tabula Rasa* (in Latin, "blank tablet") consists of an object-box-table divided into many sections with the artist's body lying underneath them. Each section contains a marker pen and visitors may use it to draw, scribble, and write on the different parts of his body. Thus, each movement of the spectator/participant is a kind of dissection, objectification, categorisation, description, and research that directly affects the artist, both physically and emotionally. The 'vitality' of his body, as it responds, feels pain, or laughs, poses questions about the direct effect of the study of 'otherness' and how the objectification of the 'other' can be seen as a form of violence. Photographs of visitors' pictographic interventions, printed in their respective sizes, replace the live body with this collection of fragments.

 The image of a helpless, nude, cold body is associated with research of the 'other': a kind of spectacle, an uncommon form of initiation, a consecration, an unveiling. The *Tabula Rasa* project targets the stereotypes of our times, when many secrets of the body have been disclosed, so the body becomes increasingly emptier and more artificial. It has been reduced to a systematised, generalised, controlled, universalised, exteriorised, tailored, reshaped, stuffed, prosthetised, objectified thing. Apart from the fact that Enlightenment scientists were the first to see the body as something dissectible, a source of information, a specimen, these processes actually reveal a colonial aspiration that is one of the practices of domination, a privilege in the production of objective truths that is similar to various forms of social engineering: anthropology, eugenics, euthanasia, sterilisation, segregation, genocide, biotechnology, birth control and death control.

186

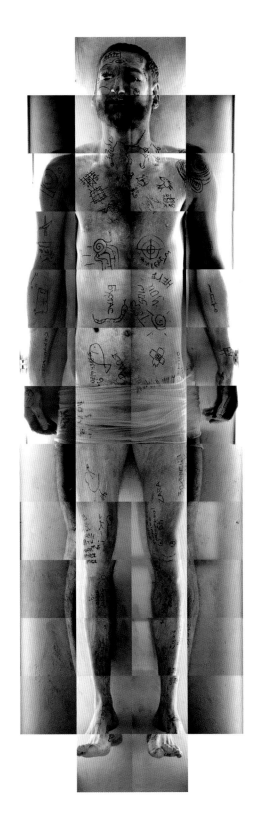

Tabula Rasa (Wunderkabinet)

Photographic documentation from performance at
the exhibition *Stay, Stay*, opening event of the Closed
Shops project, Central Mineral Bath, Sofia, 2008
200 x 60 cm
Courtesy the artist

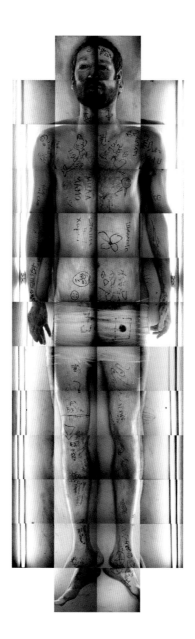

Tabula Rasa (Wunderkabinet)

Photographic documentation from performance at
the exhibition *Interactive Spaces*, organised by the
Scenographers Guild, Theatre Sofia, Sofia, 2009
200 x 60 cm
Courtesy the artist

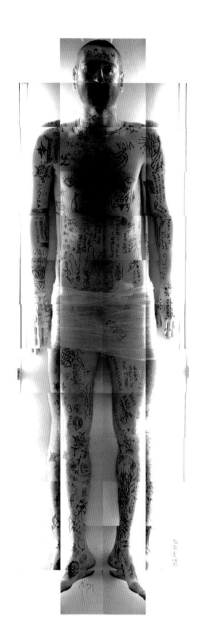

Tabula Rasa (Wunderkabinet)

Photographic documentation from performance at the Varna
Summer International Theatre Festival, Varna, Bulgaria, 2010
200 x 60 cm
Courtesy the artist

Teo Spiller

Born 1965, Ljubljana, Slovenia
Lives and works in Ljubljana

Spiller, internationally recognised in the area of net.art, has produced a graphic oeuvre of machine-generated images. His *Laboro* device (Latin for 'work'), made on the principle of the CNC machines used in serial production, employs a repetitive, rhythmic motion to leave grooves, holes, dots, and lines that create images.

In/Form/ations transforms well-known web pages into reliefs. Spiller explores subtle but complex shortcomings created by digitisation with its matrix approach. Because every hole represents a letter from the web page, as defined by its depth, a material artefact emerges from the non-material flow of digital data. Different shadows produced by different depths create a dynamic flickering as in the world of screens. Semantically, the word "information" suggests data hidden 'in form'. The structure of wood provides an excellent example: it is a chronography of the climatic and biological conditions in which the tree developed. Plywood is an industrial composite glued together in a rhythmic collage.

When the Laboro draws lines across surfaces with a felt-tip marker, this flickering is even more pronounced. Intentionally uneven, the impressions are organic and resemble bar codes; only by zooming out can we recognise the images. The installation *President Obama Watches the Execution of Osama bin Laden* is composed of fragments of the famous media image hanging as separate, loosely connected symbols. These reveal the principles of new media (copy/paste, icons and drop-down menus, windows, montage and postproduction, web page composition, tweeting, texting, clicking between TV channels with a remote), where wholes are composed of fragments. Users choose among prepared pieces of information, creating their own image of reality. Because we use the same technologies and interfaces to communicate, our interactions also become increasingly less linear, with images occupying a central place.

190

sloveniatimes.com

From the series *Wooden In/Form/ations*, 2011
Milled wood
40 x 50 cm each
Courtesy the artist

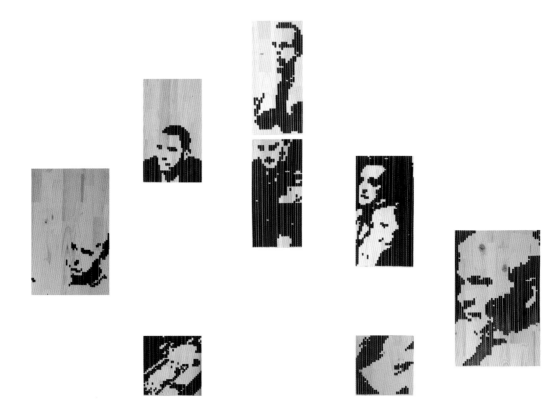

President Obama Watches the Execution of Osama bin Laden, 2013

Felt-tip marker on wood
300 x 200 cm overall
Courtesy the artist

Barack Obama, detail from the installation:

President Obama Watches the Execution of Osama bin Laden, 2013
Felt-tip marker on wood
300 x 200 cm overall
Courtesy the artist

Dario Šolman

Born 1973, Zagreb, Croatia
Lives and works in New York

The Heart of Perspective: The Making of the Film is an ongoing experimental art project that includes drawings, animation, video, storyboards, digital art, and written materials. The multimedia components are organised in an open-ended, non-linear structure and explore related visual and narrative themes. They form a series of visual/narrative modules that can be combined in different ways and allow for an interactive immersive experience. The website filmlog.org, which presents the project's development chronologically, is also an integral part of the projects. Šolman refers to his practice as "cinemation" or "secondary cinema".

Šolman has been developing his iconography over the last decade. His work is a chain of correlated modular multimedia projects that share linked visual languages and narratives. They explore similar themes inspired, in part, by science fiction, Westerns, Japanese anime, alternative and avant-garde movements, amongst other sources. Šolman's work explores the way we experience art, cinema, culture and other mythological systems, individually or collectively. The overall project in its multiple components, also comments on the way art is created from the maker's point of view.

The iconography combines simple geometric imagery, alluding to various aspects of the human condition, with a range of visual themes, such as architecture, technology, nature, science fiction, time travel, cryptography, theological and folklore semiologies, etc.. A geometric human shape dominates the project and functions as a neutral empty shell, a proxy or avatar, that is simultaneously pathetic, searching, worshipped, and enigmatic.

194

With the support of the Culture
Programme of the European Union.

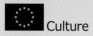

Selected digital works from the project

The Heart of Perspective: The Making of the Film

2010–2013
Courtesy the artist

Nika Špan

Born 1967, Ljubljana, Slovenia
Lives and works in Düsseldorf, Germany, and Ljubljana

Špan's *Fine Sciences* series, 2006–2007, is a group of works derived from visual material found on the Internet. It includes videos, inkjet prints, and digital files. The found materials that interest Špan are, for the most part, graphic visualisations of scientific research that were made to help people understand complex relations, interactions, and processes in specific experimental or virtual environments. Špan selected these images for her series not on the basis of their original purpose, but for their visual structures. The source material was modified after being downloaded from the Internet: .jpg, .png, .gif, or .avi files were rebuilt or sampled by the artist using various computer programs. From the downloaded and rebuilt graphic images, Špan then created tree file prints, digital graphic files, and digital videos, often with musical soundtracks.

 Fine Sciences 0213 is a new part of this series. It is based on Anders Sandberg's map of computer scientists, a graphic depiction of Ian Parberry and David S. Johnson's "SIGACT Theoretical Computer Science Genealogy". The image file has been installed in a computer programme so it can be enlarged to fill any given space. The work is printed by an inkjet printer on sheets of A4 paper, which are then assembled on the wall.

198

Fine Sciences 0213, 2013

Inkjet prints on A3 archival matte paper
Overall dimensions variable
Based on Anders Sandberg's map of computer scientists (based on the "SIGACT
Theoretical Computer Science Genealogy" by Ian Parberry and David S. Johnson)
Courtesy the artist

Fine Sciences 0407, 2007

Inkjet print on photographic paper
38 x 50 cm
Source no longer traceable
Courtesy the artist

Waltraut Tänzler

Born 1953, Bremen, West Germany
Lives and works in Berlin

The prints are screenshots from real-time videos from a surveillance programme that has been edited and furnished with appeals that come directly from this same programme. Securing a country's frontiers means encouraging its citizens to be vigilant and take part in guarding against illegal immigration and crime.

Tänzler's project draws on the first real-time public border surveillance programme, which was initiated by the Texas Border Sheriffs' Coalition in 2008 (and taken over by the Texas Department of Public Safety in 2011). A network of cameras and sensors along the Texas–Mexico border feeds live-streaming video to a website (www.blueservo.net). The worldwide Internet community is invited to participate in a "Virtual Community Watch" and support the observation of the Texas border. Users sign up to become "Virtual Deputies" in order to directly monitor activity along the border via this "Virtual Fence". They can then report any suspicious activities directly to the Texas Border Sheriffs via email.

The network also encourages the public to connect their own cameras to the network, thereby creating "Virtual Neighbourhood Watches". A new use of the social network, the Texas project works towards crime reduction through equal access to vigilance and surveillance for all. Law enforcement takes advantage of new and advanced technology, anticipating that a high volume of traffic will eventually generate enough advertising revenue to defray the programme's infrastructure and operating costs.

Border Watching, 2009–2013

Series of 13 inkjet prints on transparency film
30 x 42 cm each
Courtesy the artist

During the day if you see
[...] these young men in
a [...] report this activity.
At night if you see people
moving report activity.

If you see vehicles
parked along side of
road and or if you see
people moving late night
please report activity.

Rirkrit Tiravanija

Born 1961, Argentina; of Thai origin
Lives and works in New York, Berlin,
and Chiang Mai, Thailand

The artist's passport from 1988 to 2008 runs as a central band through each of the three scrolls and underlays or overlaps of an assortment of images, including city maps, archaeological and architectural sites, mazes, time zones, illustrations of urban flow, notebook pages, and recipes. This work essentially chronicles the last 20 years of his life, his recurring themes and historical references. The maps and arrows record locations where Tiravanija has travelled and exhibited. There are recipes that refer to his practice of preparing and feeding visitors at his exhibitions. Interspersed throughout each of the three scrolls are repeated silhouettes of iconic art works by Marcel Duchamp and Marcel Broodthaers. Duchamp's famous *Fountain,* 1917, inspired Tiravanija to become an artist, while in the 1960s and 1970s, Broodthaers' incorporation of mussels in cooking pots as appropriated objects clearly influenced Tiravanija's own cooking performances and installations.

untitled 2008–2011 (the map of the land of feeling) III, 2008–2011 (detail)

Edition of 40 / 1 BAT / 1 Neiman Archive / 1 HC / 10 APs
Archival inkjet, offset lithography, chine collé, collage, and silkscreen on Strathmore
Published by the LeRoy Neiman Center for Print Studies, Columbia University, New York
Courtesy the LeRoy Neiman Center for Print Studies

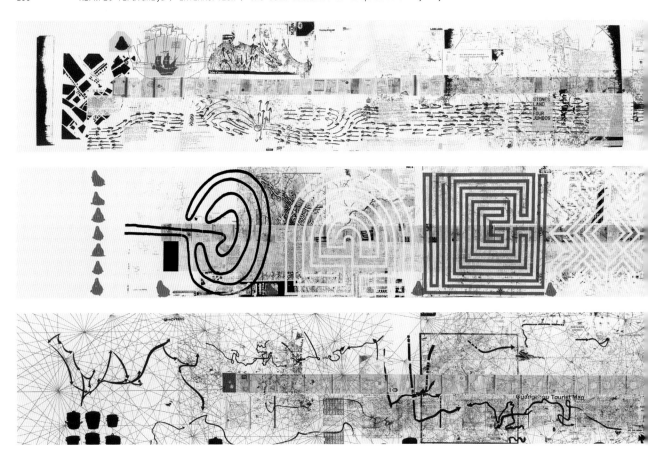

untitled 2008–2011 (the map of the land of feeling) I–III, 2008–2011

Edition of 40 / 1 BAT / 1 Neiman Archive / 1 HC / 10 APs
Archival inkjet, offset lithography, chine collé, collage, and silkscreen on Strathmore
Published by the LeRoy Neiman Center for Print Studies, Columbia University, New York
Courtesy the LeRoy Neiman Center for Print Studies

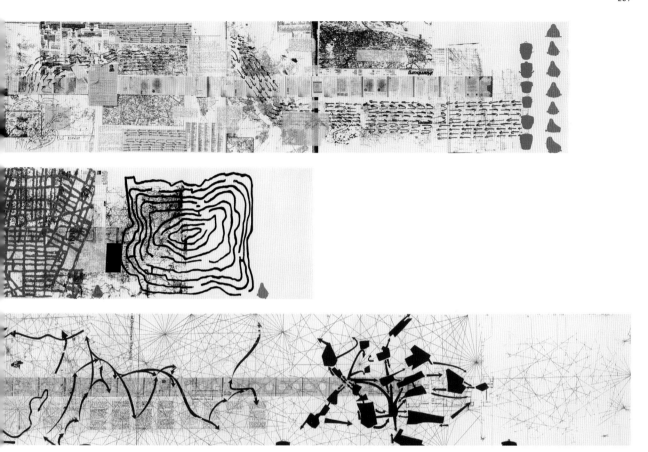

Vargas-Suarez Universal

Born 1972, Mexico City, Mexico; raised in Houston, USA
Lives and works in Brooklyn, NY, USA

Rafael Vargas-Suarez, more commonly known as Vargas-Suarez Universal, was raised in the Houston suburb of Clear Lake City, adjacent to NASA's Johnson Space Center. From 1991 to 1996, he studied astronomy and art history at the University of Texas at Austin; he moved to New York in 1997. He is primarily known for large-scale *in situ* wall drawings that consider existing architectural elements as well as local issues and concerns. He is also recognised for his paintings, drawings, and sound recordings sourced from the US and Russian manned and unmanned space-flight programmes, astronomy, and aerospace architecture. His post-studio research is conducted at the space centres in Cape Canaveral, FL; Houston; Korolyov (Moscow Oblast), Russia; and Baikonur, Kazakhstan.

210

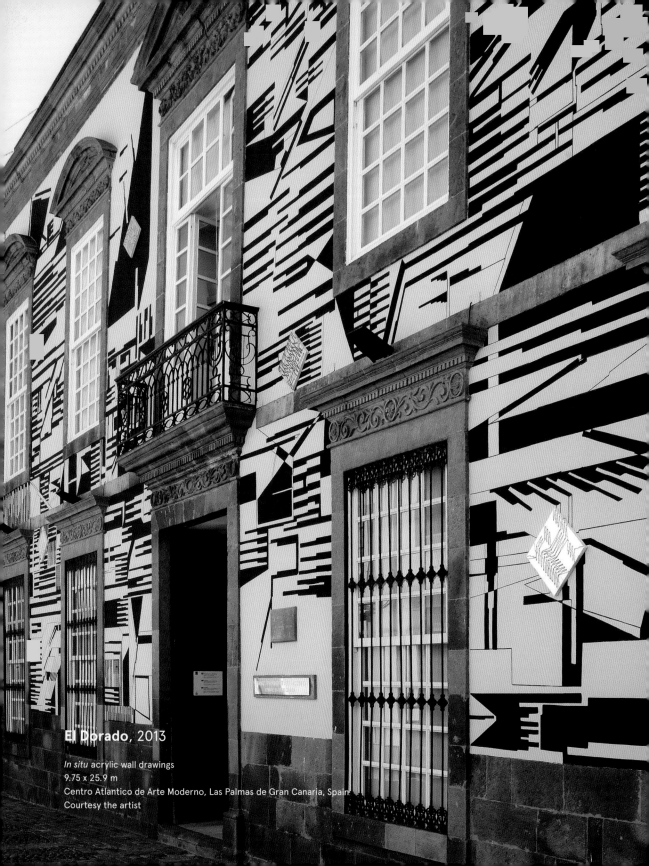

El Dorado, 2013

In situ acrylic wall drawings
9.75 x 25.9 m
Centro Atlantico de Arte Moderno, Las Palmas de Gran Canaria, Spain
Courtesy the artist

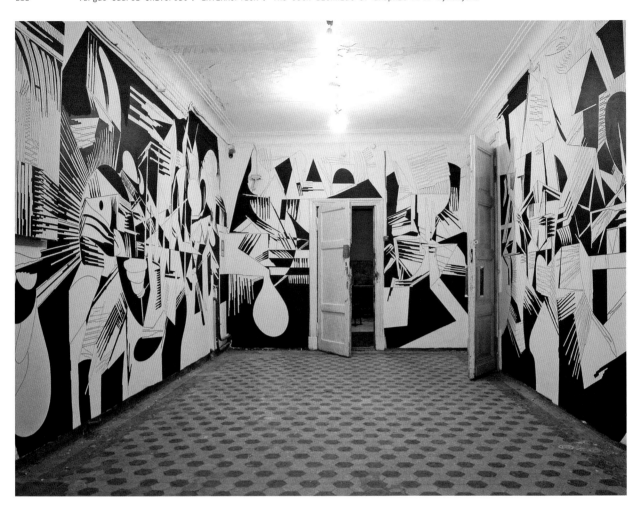

Space Station: Friendship, 2007

In situ ink and acrylic wall drawings
3.5 x 12.32 x 3.04 m
Permanent installation at the Winzavod Contemporary Art Centre, Moscow
Courtesy the artist

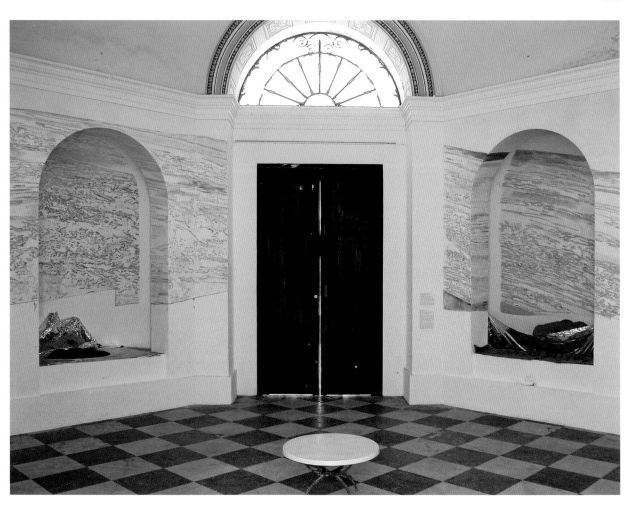

Outcrop: Distributary Flow, 2012

In situ coffee wall drawings, coffee beans, coffee skins, coffee bags, thermal blankets
6.51 m (dia.) x 4.57 m (high)
Commissioned by Pablo Rodriguez, San Juan, Puerto Rico
Materials and technical assistance provided by Luis Valdejuly Sastre, Cafe Mayor, Ponce, Puerto Rico
Trienal Poli/gráfica de San Juan, Latinoamérica y el Caribe: El Panal/The Hive,
Chapel, Antiguo Arsenal de la Marina Española, Old San Juan, Puerto Rico
Courtesy the artist

Tomas Vu-Daniel

Born 1963, Saigon, South Vietnam; raised
in El Paso, TX, USA after 1973
Lives and works in New York

Vu-Daniel's work presents his interpretation of the world as a meeting place of memory and imagination. He is interested in cycles of destruction, in decay and rebirth, repeating and distorting images that engage nature's capacity for a symbiotic relationship between violence and compassion. His prints, paintings, and installations often incorporate biological or viral motifs, evoking the strata of atmosphere, landscape, memory, and time. They isolate, distort, and displace surfaces and space. Pockets of activity appear randomly and develop, spread, interact, and evolve. While alluding to the ambiguous nature of reality and the beauty of inevitable ruin, Vu-Daniel also addresses postmodern and poststructuralist ideas behind the destabilisation of fixed meaning. In his worldview, when cataclysmic events mesh with the natural order of things, beauty counterbalances horror.

In this series, the artist makes reference to his childhood in Vietnam, the culture of surfing, and the influence of Western popular music. He carefully crafts wooden surfboards, sends them to friends to use, and then retrieves them. He engraves each with the lyrics of songs from particularly resonant albums, along with dense passages of line: complex network structures and spatial relationships drawn from nature, art, body systems, celestial constellations and space exploration, city sprawl, and human decay.

214

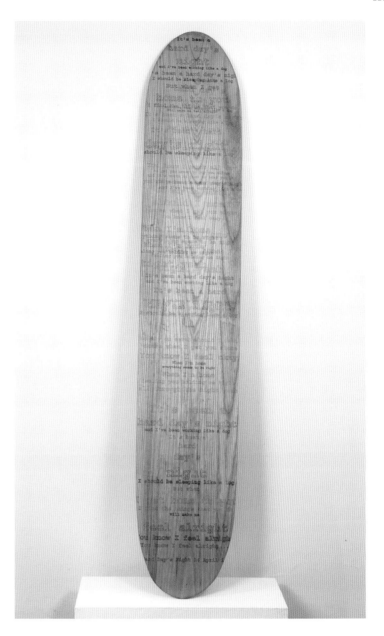

Songs from The Beatles' "The White Album" (1968), 2013

Shaped and laser-engraved paulownia wood, coated with linseed oil
188 to 228.6 cm (high) x 48.3 to 55.9 cm (wide)
Courtesy the artist

Songs from The Beatles' "The White Album" (1968), 2013

Studio installation view
Courtesy the artist

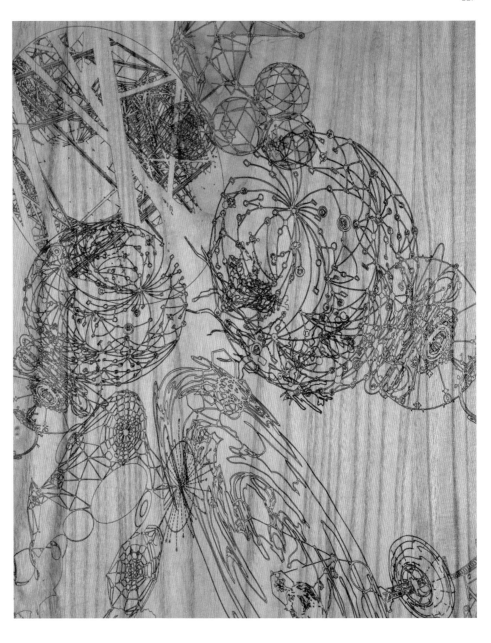

**Songs from The Beatles' "The White
Album" (1968)**, 2013 (detail)

Courtesy the artist

Regina José Galindo:
The Anatomy Lesson

Yasmin Martín Vodopivec

Grand Prize Winner, 29th Biennial of Graphic Arts Ljubljana

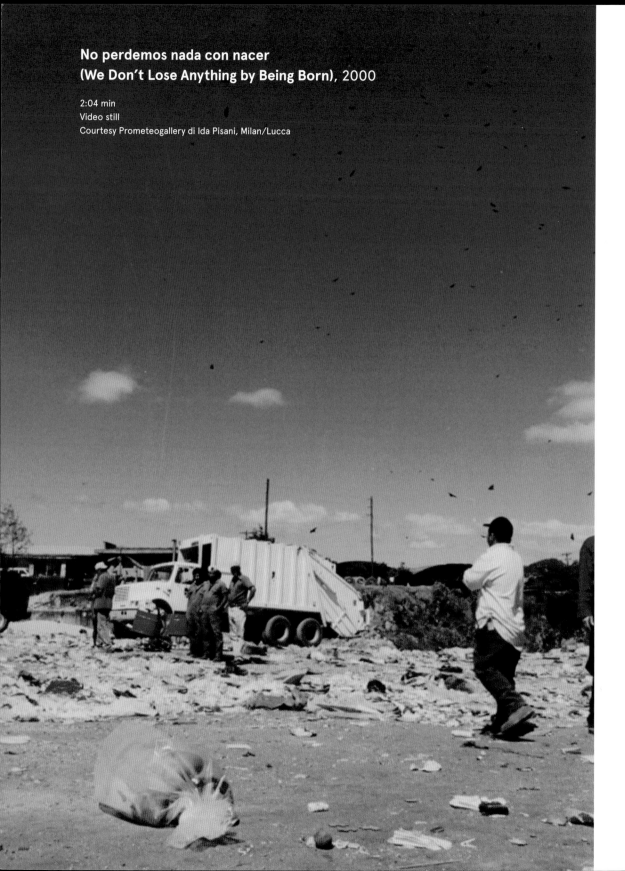

**No perdemos nada con nacer
(We Don't Lose Anything by Being Born)**, 2000

2:04 min
Video still
Courtesy Prometeogallery di Ida Pisani, Milan/Lucca

Not through blows,
but gazes.
Hundreds of white larvae
watching us from the bottom of empty sockets
more painful than a thousand kicks.

—Regina José Galindo

In the beginning was the word. Regina José Galindo's performances began their journey with poetry. She belongs to the generation of Guatemalan artists who grew up during the most violent period in the country's history and whose careers developed in the years of political liberalisation and modernisation after the end of Guatemala's Civil War (1960–1996).

Despite there being only a single precedent for performance art in Guatemala—that of Margarita Azurdia, who did several art actions during the war (although they are not well documented)—the medium became an important form of artistic expression towards the end of the 1990s, thanks to the new openness in the political climate, the restoration of civil rights, and the reclaiming of public space.[1]

Regina José Galindo's involvement in the world of performance came naturally, under the influence of other writers and artists she knew and from a need to express herself, to realise the strong poetic charge of the body as a way "to put an image to words".[2]

Galindo's transition from poetry to performance is hardly an isolated case. Many who started as writers have gone on to explore—in visual art, music, and performance—the possibilities of poetry beyond poetry. As a catalyst for crafting the intended message, performance art presents a number of formal and functional connections with poetry—in the materialisation of the subject, the object, and the action itself. This expansion in search of a different kind of reception thus seems natural. The formal connections between poetry and performance are many, but perhaps one of the most prominent is that of rhythm and, by extension, energy.[3] Rhythm is fundamental to poetic language and is responsible for a coherent distribution of energy. Formalist poetics, in particular, stressed its importance, going so far as to assert that every poet possesses a unique and individual rhythm. As Charles Olson wrote in his manifesto *Projective Verse*, where he argued for a poetics based on sound and perception rather than syntax and logic: "A poem is energy transferred from where the poet got it…, by way of the poem itself to, all the way over to, the reader.… Then the poem itself must, at all points, be a high energy-construct and, at all points, an energy-discharge."[4] Just as the poetic system is formed to reach an audience through the creation and selection of syntactic structures, words, and inflections, the mechanisms in performance art work similarly, with the same processes influencing the structure and function of the elements. This opens up a space where action becomes embodied in rhythm and

NOTE Regina José Galindo (born 1974, Guatemala City) was awarded the Grand Prize of the 29th Biennial of Graphic Arts. An exhibition of her work, curated by Yasmín Martín Vodopivec, is presented at the Jakopič Gallery (part of the Museum and Galleries of Ljubljana), September 14–November 24, 2013.

1 Also known as Margot Fanjul, Azurdia (1931–1998) was a Guatemalan artist who worked in sculpture, painting, poetry, performance, and modern dance. In her work, she assimilated the local culture and reflected on gender in the context of Guatemala's Civil War. She also explored representations of the body's movement through bodily experiences carried out in both art galleries and public spaces as the most immediate way to force audiences to react. With her first performance, *Favor quitarse los zapatos* (*Please Take Off Your Shoes*, 1970), Azurdia became the first artist from Central America to participate in an international biennial with an individual performance piece. The work invited the public to walk barefoot over a sand-covered floor in a cavernous wooden construction. As Rosina Cazali notes, "Like other Latin American artists from the same period, such as Lygia Clark and Hélio Oiticica, Azurdia was interested in integrating the body of the public in the work, exploring sensorial capacities other than vision and expanding psychophysical awareness. Since this first performative experiment, she has continued to explore the earth element in her poetry and ritualistic dances." ("Margarita Azurdia: Favor quitarse los zapatos", *Re.Act.Feminism: A Performing Archive*, http://www.reactfeminism.de/entry.php?l=lb&id=282&e=a [accessed 28 June 2013].)

2 Quoted in the television documentary *Metrópolis: Regina José Galindo*, directed by María Pallier, Radio y Televisión Española, 16 March 2012, available online at http://www.rtve.es/television/20120309/regina-jose-galindo/506166.shtml, accessed 28 June 2013.

3 Santos, Brama, "Poesía y performance: La manera más precisa de conocer la realidad y la vida" (2003), *Performancelogía*, http://performancelogia.blogspot.com/2008/01/poesa-y-performance-la-manera-ms.html, accessed 28 June 2013.

4 Olson, Charles, *Projective Verse*, New York: Totem Press, 1959.

energy. And when this energy reaches a certain intensity, a state of identification is created and the possibility of interaction on different levels is reaffirmed. The conceptual world associated with the possibilities of poetry—beyond aesthetic pleasure and didactic or utilitarian goals—and notions about the poet as the transmitter of the collective heritage, or as a social subject, help to materialise the intentionality of a socially and politically committed poetry through action.

These principles can be seen in the way Regina José Galindo first presented herself. This was in February 1999 in the group show *Sin pelos en la lengua* (*Not Mincing Words*), today considered a landmark because it introduced the main practitioners of performance art in contemporary Guatemala.[5] In her work *El dolor en un pañuelo* (*Pain in a Handkerchief*), Galindo, tied to a vertcally positioned bed, denounced the rapes and abuses committed against women in Guatemala while newspaper articles about these atrocities were projected onto her body. This work was followed by her first solo performance, produced with the help of the commissioner Belia de Vico, *El cielo llora tanto que debería ser mujer* (*Heaven Weeps So Much It Should Be a Woman*). Here the artist held her breath under water in a bathtub, forgoing speech and putting her body to the test as a way of expressing the asphyxia of women's silence. That same year, in the performance *Lo voy a gritar al viento* (*I'm Going to Shout It to*

the Wind), Galindo had suspended herself from the archway of the main post office in Guatemala City and read out poems into the air, then tossed these unpublished texts down to onlookers, as a way of protesting social repression in the public and private spheres.

Guatemalan poetry in the second half of the twentieth century was characterised by political engagement in the 1950s, with new themes such as the body, sexuality, feminism, and the urban experience introduced in the following decades.[6] Poetry in the years since the Civil War has been influenced by the development of new technologies, neoliberalism, and globalisation.[7] This post-war generation has introduced sculptural imagery and visual rhythms, looking back on the collective history from the vantage point of the start of a new century.[8] At a moment when "fiction was regarded by many as an apolitical position, a way of avoiding the urgency of working towards change", when it was impossible to separate the political and social contexts and a process to recover civil rights had begun, some Guatemalan writers decided to expand their poetic experience by approaching it from various perspectives that included visual imagery and performance. In this way, artists became involved with performance art, using it as a new way to explore the disturbing consequences of 36 years of war, genocide, and the violation of human rights.[9] The poetry of the generation born in the 1970s, while marked by the vestiges of

5 Pérez-Ratton, Virginia, "Performance and Action Work in Central America, 1960–2000: Apolitical and Aesthetic Choice", *Arte≠Vida: Actions by Artists of the Americas 1960–2000*, Deborah Cullen ed., New York: El Museo del Barrio, 2008, p. 210.

6 Guatemalan literature in this period addressed such topics as protest, rebellion, hope, pain, solitude, fear, and death. Lyric poetry constructed a renewed vision of poetic language and the memory of a country torn apart by a war that destroyed people, history, and conceptual worlds. In lyric poetry, the subjective 'I' stimulated the reader's interpretive capacity while forging a dynamic system that operated as both the product and producer of signification, with a deliberate social positioning. The writers of this period who have influenced Galindo include Alaíde Foppa, Luz Méndez de la Vega, Manuel José Arce, Ana María Rodas, Roberto Obregón, Isabel de los Ángeles Ruano, and especially Marco Antonio Flores, whom Galindo views as her great mentor.

7 The Guatemalan Civil War began in 1954, when President-elect Jacobo Arbenz was overthrown in a coup planned by the US Central Intelligence Agency. With CIA support, the military leader Carlos Castillo invaded Guatemala and seized power, which he held until his assassination in 1957. He was succeeded by General Miguel Ydígoras Fuentes, who came to power in 1958. In 1960, a group of young army officers tried to organise a revolution, which failed. Several of these revolutionaries went into hiding and established close ties with the Cuban government. This group became the core of the force that organised an armed rebellion against the government over the next 36 years. Armed conflict officially came to an end on 29 December 1996, with the signing of the Agreement on a Firm and Lasting Peace. During the unrest, some 140,000 people died in clashes between the guerrilla movements, government forces, and the civilian population. In addition, some 44,000 people disappeared and 50,000 farmers were forced to leave their land.

8 Toledo, Aída, and Anabella Acevedo, "Cuando el poeta novísimo despertó la tradición todavía estaba allí", *Tanta imagen tras la puerta: Poetas guatemaltecos del siglo XXI*, Guatemala City: Abrapalabra, 1999, pp. 11–17.

9 Contreras Castro, Anabelle, "Despolitizar como acción política en la Centroamérica contemporánea", *E-misférica*, vol. 8, no. 1, 2011; http://hemisphericinstitute.org/hemi/es/e-misferica-81/contreras., accessed 28 June 2013.

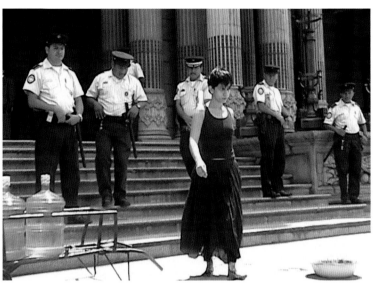

¿Quién puede borrar las huellas?
(Who Can Erase the Marks?), 2003 (top)

37:30 min
Video still
Courtesy Prometeogallery di Ida Pisani, Milan/Lucca

Esperando al príncipe azul
(Waiting for Prince Charming), 2001 (bottom)

Photograph by Andrea Aragón
Courtesy Prometeogallery di Ida Pisani, Milan/Lucca

defeated revolutionary hopes, extreme violence, and the complex transition process, does not directly reference that history but instead denotes disenchantment, irony, scepticism, boldness, and provocation. These same emotions are distilled in Galindo's works.

In her early performances, the relationship with poetry was made clear through the presence of words and the exploration of the body's poetic charge—a body often rendered motionless. In later works, however, she began to interrogate the mechanisms and practices of performance itself, informed by the work of such artists as Jessica Lagunas, Aníbal López, Rosemberg Sandoval, María Teresa Hincapié, Marina Abramović, and Chris Burden. Other references later appeared—such as Ana Mendieta, Teresa Margolles, Gina Pane, and Santiago Sierra—and Galindo ended by asking questions based on the supposed absence of the corporeal. In works such as *No perdemos nada con nacer* (*We Don't Lose Anything by Being Born*), 2000, Galindo wrapped herself in a clear plastic bag and was thrown into Guatemala City's sewage system, where human remains sometimes turn up unnoticed. The poetic remains a constant in her development, independent of her expanding themes and use of different devices and strategies.

The poet's function as a social subject in Guatemalan poetry—where the object was the reality of the country's political and social context—re-emerges in Galindo's performance practice as a subject and object that are one and the same, with their respective functions alternating throughout her career: from a coinciding of subject and object; to a subject that becomes an object, or becomes an object only to become a subject again through the gaze of the observer; to the objectification of artistic practice itself. The goal of all this is to construct metaphors for social injustice, the fragmentation of identity, the discontinuities of collective memory, social pathologies, the paradoxes of systems of power, and their repercussions in different environments of the globalised society.

Galindo's performances are charged with a symbolic content in which the body stands for the fragility of individuals, the painful irrelevance of others, and the systematic harassment of the authorities. Because of this dissected otherness, her work produces anything but indifference. The others are always the others, but for some reason they end up being us, because, despite what makes us different, there is always something that unites us, even if the only thing that makes us feel united is our own human nature.

In the years before peace, repression created the social perception of the naked body as a symbol of punishment, associating it with torture, rape, and abuse. Galindo breaks into the world of art using her body as a tool to represent marginality, even in the sense of the individual identity in the face of the others. In all her performances, Galindo explores different combinations of individuality and collectivity, examining them with the subtlety of a scalpel. As Foucault argued:

> Maybe the target nowadays is not to discover what we are, but to refuse what we are. We have to imagine and to build up what we could be to get rid of this kind of political 'double bind', which is the simultaneous individualisation and totalisation of modern power structures.[10]

Galindo's dissection of the individual and society reflects Foucault's thought on two levels. On the one hand, her performances continually interrogate our present condition and demand a specific attitude towards it. On the other, her work reveals the conflicted bipolarity to which we are subjected by our own submission to the ideological apparatus, which, even as it individualises and isolates us, places us in the framework of collective categories.

The strategies Galindo employs move back and forth between two poles: poetic language and bodily action; the individual and the collective; the global and the local. She seeks to expand our experiences, whether through her practice or through the sum of these practices. Galindo reveals what we do not see, although it exists, or what exists behind what we see, as in the performance *Punto Ciego* (*Blind Spot*), 2010, where the artist displays her naked body in an exhibition space that only blind people are permitted to enter. The performance provoked a series of reactions which revealed the contrast between the weakness of human nature and the problematic foundations of social structures.

Galindo's early work vivisects identity in all its facets, analysing such issues as gender identity, cultural identity, and social identity. She questions the parameters of individuality, the feminine, and marginality, and denounces male violence, the

10 Foucault, Michel, "Why Study Power: The Question of the Subject", *Michel Foucault: Beyond Structuralism and Hermeneutics*, Hubert L Dreyfus and Paul Rabinow eds., Chicago: University of Chicago Press, 1983, p. 216.

social position of women, and the way power classifies individuals. These issues are reflected in a number of her works: in *Esperando al príncipe azul* (*Waiting for Prince Charming*), 2001, she was covered by a wedding-bed sheet with a small opening for the vagina; in *Angelina*), 2001, she spent a month as a domestic servant and watched how her day-to-day activities changed; in *Perra* (*Bitch*), 2005 she inscribed the title of the work on her body to memorialise similar inscriptions made on the bodies of tortured women; and in *Mientras, ellos siguen libres* (*Meanwhile, They Are Still Free*), 2007, she denounced the systematic rape of pregnant indigenous women during the armed conflict in Guatemala. The horror and indignity reflected in such an "aesthetics of violence" (to use Anabella Acevedo's term) speaks to us, through signs, of fragmented identity and hopelessness, while the effects of violence are revealed in artistic practice, not mimetically, but by turning the historical into metaphor in order to speak of conflicts of a more existential nature.[11]

In 2003, when the Guatemalan Constitutional Court approved the presidential candidacy of former dictator Efraín Ríos Montt (who ten years later would be tried for genocide and crimes against humanity), Galindo decided to make the performance *¿Quién puede borrar las huellas?* (*Who Can Erase the Marks?*). She walked through the streets of Guatemala City, from the Constitutional Court to the Presidential Palace, carrying a basin full of human blood. Every so often she would stop, dip her feet into the basin, and take a few steps, leaving bloody footprints on the pavement. This was subject as both victim and victimiser; the lacunae of memory, resurfacing to remind us that they are not so far away; a plea against discrimination, against the slavery of the mind, against terror and abuse and the methods of the authorities, whose primary tactic is to ask questions but never provide answers. Uneasiness assails us in other works, too, such as *Hermana* (*Sister*), 2010, where an indigenous Guatemalan woman slaps, spits, and punishes the artist's mestizo body; or the installation *La conquista* (*The Conquest*), 2009, where human presence is evoked through absence—the presence of women, the victims of the black market, who

sell their hair in order to survive; or *Limpieza social* (*Social Cleansing*), 2009, where the artist is subjected to a high-pressure shower similar to the one given new inmates when they arrive in prison or the water cannon used to suppress public protests.

The subject is objectified in Galindo's work through strategies such as isolation, confinement, and disqualification, and these are what produce identification, as Foucault reminds us: "I have studied the objectivising of the subject in what I shall call 'dividing practices'. The subject is either divided inside himself or divided from others. This process objectivises him."[12] In this process, human beings are given a social and personal identity. The subject objectified in the body of the artist is a collective body, the body as an object of power, as the social body, which, as Foucault also noted, "is the effect... of the materiality of power operating on the very bodies of individuals".[13] The artist's analysis of the origin, causes, and effects of power transcends the reality of identity and geographic context, to reach a global audience and create experiences of catharsis. In certain works, she directly involves others as part of the collective. In *Pelotón* (*Platoon*), 2011, for instance, she assembled a convoy of private security police to denounce the population's scepticism about national security bodies and the appearance in Guatemala of armed but untrained professionals—such as private security police. In *Marabunta* (*Throng*), 2012, meanwhile, she hired a group of men to take apart a car and make it disappear in the centre of the city.

The artist continues to dissect society, power systems, and the paradoxes of globalisation, with identification and recognition as key tools in her process. In *Looting*, 2010—the title is in English—the artist had her teeth inlaid with pure Guatemalan gold, only to have the gold removed in Germany. In *Juegos de Poder* (*Power Games*), 2009, she obeyed commands while in a state of hypnosis. In *Clase de disección* (*Lesson of Dissection*), 2011, under the attentive gaze of a group of anatomy students, she explored the rise in the professionalisation of violence.

Awareness of the heterogeneous collective nature of the various social identities is what allows the viewer to identify with the object,

11 See Acevedo Leal, Anabella, "La estética de la violencia: Deconstrucciones de un identidad fragmentada", *Temas Centrales: Primer simposio centroamericano de prácticas artistícas y posibilidades curatoriales contemporáneas*, San José, Costa Rica: TEOR/éTica, 2000, pp. 97–107.

12 Foucault, "Why Study Power", p. 208.

13 Foucault, Michel, "Body/Power", *Power/Knowledge: Selected Interviews and Other Writings*, Colin Gordon ed., New York: Pantheon, 1980, p. 55.

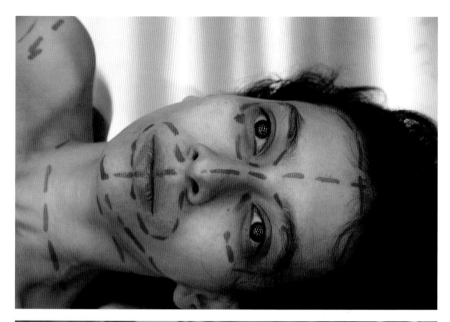

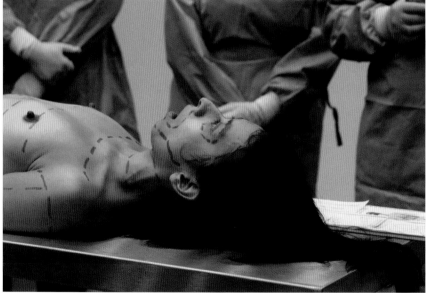

Clase de disección
(Lesson of Dissection), 2011

37:00 min
Video stills
Courtesy Prometeogallery di Ida Pisani, Milan/Lucca

in one way or another, through the different stages that take place in identification. This process can involve the viewer's direct affinity with the object, or it can be a state of partial fusion that arises in a moment of confusion, when, under the blurry perception of a denial produced after observation, the viewer comes to identify once more with the object, even if this means relying on the identification reinforced by a third party (whether ourselves or someone who joins us in the experience). This translates into a process of localising the viewing subject once more in relation to the performance and the surrounding reality. The other, ultimately, is the self, as reflected in that other, which is now not only the object but also the subject with which the viewer identifies—a single image in which we see ourselves reflected, bounced back to us, because, "in a way, all of Regina's actions work like a mirror, but they are also like a shot hitting its target".[14] And what hits the target is the same energy Jacques Rancière discusses in *The Emancipated Spectator*: the intelligence that is constructed when subject and object consent to power, with the object maintaining the action and the subject reactivating the power.[15]

If the effectiveness of the reflection is inversely proportional to distance, Regina José Galindo is that 'ignorant schoolmaster' who dismisses the distance between her knowledge and our ignorance, our inexperience being what we still don't know in contrast to what the master has mastered.[16]

In this case, distance is not an absolute evil, but rather the normal condition of all communication. As the artist herself notes, "Performance art raises questions, it does not give answers", which is why she is interested in creating experiences "where linear relations between the audience and the work of art may be modified or may shift.[17] It is important to break the moulds in any transfer of information so that knowledge does not stagnate".[18]

We could say that, in fact, there is no protest in Regina José Galindo's work, but only the firm invitation to live an experience. The artist does not show us some previously made experience, the paths of her own knowledge; instead, she reveals her willingness to offer us the tools we need to find our own path, to abandon the apparent passivity of one who contemplates and be carried away so as to activate the capacities of our senses, our emancipatory experience. As the Serbian author Danilo Kiš wrote in *The Anatomy Lesson*:

> The world does not begin today, and we know, we see, that this is not the first anatomy lesson under the sun, but it is still possible to learn new things through observation, dissection, vivisection, practice and the sum total of the experiences accessible to us.
> The lesson may begin.[19]

Translated by Odile Cisneros

14 Castro Flórez, Fernando, "Las encarnaciones atroces de Regina José Galindo", *Regina José Galindo*, Milan: Silvana Editoriale, 2011, p. 25.

15 Rancière, Jacques, *The Emancipated Spectator*, Gregory Elliott trans., London: Verso, 2009. Rancière is writing about theatre, but his idea is equally relevant for performance art: "Theatre is the place where an action is taken to its conclusion by bodies in motion in front of living bodies that are to be mobilised. The latter might have relinquished their power. But this power is revived, reactivated in the performance of the former, in the intelligence which constructs that performance, in the energy it generates", p. 3.

16 For Rancière's discussion of the "ignorant schoolmaster", see *The Emancipated Spectator*, pp. 10–16.

17 Quoted in Beatriz Colmenares, "Regina José Galindo: retrato hablado", *El Periódico de Guatemala*, online edition, 25 March 2012, http://www.elperiodico.com.gt/es/20120325/pais/209978, accessed 28 June 2013.

18 Quoted in the artist's biography, "Regina José Galindo", on the website for the International Encounter of Medellín, Medellín, Colombia, http://mde11.org/?page_id=662, accessed 28 June 2013.

19 Kiš, Danilo, *Čas anatomije*, 1978; Zagreb: Globus, and Belgrade: Prosveta, 1983, p. 12. Danilo Kiš (1935–1989), whose Jewish Hungarian father and other relatives died in Auschwitz, grappled in his fiction with the worst horrors of twentieth-century Europe. Hounded by the Communist elite after the success of his short story collection, *A Tomb for Boris Davidovich*, 1976, Kiš moved to Paris, where he wrote his book-length essay *The Anatomy Lesson* in 1978, which is seen as his "book of redemption". In it he develops the title image as a metaphor for art—a bloody feast that triumphs over banality, mediocrity, and totalitarian ideologies.

Miklós Erdély:
The Original and the Copy
+ Indigo Drawings

Annamária Szőke

Honourable Mention Recipient, 29th Biennial of Graphic Arts Ljubljana

From the early 1970s on, Erdély was continually engaged with the question of the original and the copy, or in a wider sense, with the problematics of pictorial representation, and many of the works he produced in the spirit of 'a new concept of art' are related to these 'traditional' questions. The photographs in the exhibition are the logical and, in part, technical antecedents to the indigo (carbon paper) drawings on view, about which he said the following in 1983:

> The whole indigo thing originates from the fact that I wanted to examine the representation aspect of art... *ad absurdum*. The representative character of art. I thought that this is a phenomenon of magical conception, that artistic depiction is the remains of magic in our contemporary world. And if this is the remains of magic, then this should be carried out *ad absurdum*.[1]

Two years earlier, in another interview in which he referred to representation itself as a tautology, he spoke of transcending the traditional, tautological relationship of the original (the depicted) to the copy (the depiction) as something desirable ("the task of the artist is precisely to break out of this, like a fish leaping out of water"), taking Joseph Kosuth's work *One and Three Chairs*, 1965, as his point of departure:

> I approached [conceptual art] in such a way that the subject of art is engagement with art, i.e. as Kosuth represented this. Since it is rare to see the depicted and the depiction simultaneously, this had its own effect of disturbing consciousness.[2]

And he outlined the processing of this method of disturbing consciousness in his own work as follows:

> If something happens to be identical to what is next to it, it has a magical effect. When this [registered in me], I did the following: the point is that there should be no difference between the original and the copy.... At the same time, they should appear simultaneously, in an identical context. That is, where possible, on a single sheet of paper, on a single surface.[3]

He realised this project with his 'photographic' work, entitled *Eredeti és másolat egy közegben* [*Original and Copy in the Same Medium*], 1974, followed by a technical innovation with his indigo drawings (from 1977).[4] The theoretical foundation can be considered first and foremost his writings *Ismétléselméleti tézisek* [*Theses on the Theory of Repetition*] and *Azonosításelméleti vizsgálatok* [*Studies in the Theory of Identification*], which were first published in mid-1972.[5] Erdély most probably worked on the illustrations for these theoretical texts beginning in the summer of 1971. They are photographic works in which the photos of two identical or similar things appear one above the other, and joining these two, at the bottom, is another print (a copy) of a picture made from the first one. In connection with the first two images, he used the expression 'duplicate', and in his *Theses on the Theory of Repetition,* he mentions

NOTE The project *Unguarded Money*, 1956, by Miklós Erdély (1928–1986) received Honourable Mention at the 29th Biennial of Graphic Arts. An exhibition of Erdély's work, organised in cooperation with the Miklós Erdély Foundation (EMA), is presented at the Museum of Modern Art Metelkova (MSUM), in Ljubljana, September 14–November 24, 2013. This selection has been presented previously in two locations, the Vintage Gallery (22 March–22 April 2011) and Kisterem Gallery (22 March–15 April 2011), both in Budapest. The accompanying text to the exhibition, of which an abbreviated version is reprinted here, was first published online: http://arthist.elte.hu/Tanarok/SzoekeA/EM/EM_Eredeti+Indigo_2011_elemei/page0001.htm.

1 Erdély, Miklós, "Beszélgetés Erdély Miklóssal, 1983 tavaszán" "In conversation with Miklós Erdély, spring 1983", interviewed by Miklós Peternák, *Árgus*, vol. 2, no. 5, 1991, pp. 81–82.

2 Erdély, Miklós, "Új misztika felé. Sebők Zoltán beszélgetése Erdély Miklóssal" "Towards a new mysticism: Zoltán Sebők in conversation with Miklós Erdély", interviewed by Zoltán Sebők, *Híd* [Bridge], 1982–1983, pp. 368–369.

3 Erdély, "Beszélgetés Erdély Miklóssal, 1983 tavaszán", pp. 81–82.

4 See also Peternák, Miklós, "Die Heroische Zeit der großen Illusion" (pp. 220–221), and Erdély, Miklós, "Identifizierungstheoretische Untersuchungen und Wiederholungstheoretische Thesen", pp. 222 and 224, both in *Blickmaschinen oder wie Bilder entstehen. Die Zeitgenössische Kunst schaut auf die Sammlung Werner Nekes*, Nike Bätzner, Werner Nekes and Eva Schmidt eds., Cologne: DuMont, 2008.

5 See also the bibliography of the journal *Expresszió Önmanipuláló Szétfolyóirat* [*Self-manipulating rambling periodical of expression*] compiled by Csilla Bényi in *Ars Hungarica*, nos. 1–2, 2008, p. 378.

several types of duplicates, which he then implemented in photographic works. Collating all of the documents, we are aware of eight types, but there are illustrations for only seven of them: the human duplicate (twins), the psychic/psychological duplicate (déjà vu), as well as the typographical, industrial, random, astronomical, and 'special' duplicates, of which the last is a spiritist phantom image (in the case of the individual types, a number of variations were also made within these). László Beke published the series of prints, along with Erdély's *Theses*, at the end of an essay entitled "Ismétlődés és ismétlés a képzőművészetben" ["Recurrence and Repetition in the Visual Arts"], in a volume of papers from the conference "Ismétlődés, párhuzamosság, ritmus" ["Repetition, Parallelism, and Rhythm"] organised in 1973 at the Institute of Literary Sciences of the Hungarian Academy of Sciences (MTA) (the conference papers were published in 1980).[6] The subject of Beke's essay, in part, also covered the artistic problematic of the copy and the depiction, from the beginnings to conceptual art. In 1974, Erdély made his 'photo-graphic' work *Original and Copy in the Same Medium*—a scribble made in pencil and a photograph of it on the same sheet of photo paper—about which he later said: "This was produced at first with a lot of suffering through the method of photography for [my] first Wrocław Triennial, but I found this difficult, and then I realised that with a roll of indigo (carbon) paper, this could be produced with ease."[7]

In 1977, Erdély 'discovered' indigo paper as a solution to the problem of depiction that interested him in connection with the issue of the original and the copy. He rolled indigo (carbon) paper and the drawing paper it was placed on into a cylinder, and in this way, a copy (or copies) of the form drawn on the top layer of the cylinder appeared on the same surface of the sheet of paper when it was unrolled, only a little fainter. The application of telex paper, i.e. a "roll of paper with one side coated with copying material", was

his ultimate solution, around 1979–1980.[8] The use of indigo paper was primarily conceptual, and Erdély's experimentation with the technique described above resulted in numerous variations that illustrated newer and newer semantic relations in terms of his conceptual point of departure. Among the variations belongs, for example, *Szétmásolt rajz* [*Copied-Apart Drawing*], 1978, whose central motif (a black X-shaped cross on a red 'ball', both enclosed in an outline) Erdély then 'copied to pieces': with the cross at the upper left, the ball at the lower right, the outline at the upper right, and a copy of the outline's hatched shading visible at the lower left.[9] Erdély won Second Prize at the Wrocław International Triennial of Drawing in 1978 with his *Copied-Apart Drawing,* where, according to László Beke,

> from the viewpoint of the subject of drawing, he created perhaps the most relevant pieces in the exhibition. With the aid of indigo paper, he worked out a procedure that functions precisely on the borderline between the unique and the multiplied. The gesture of freehand drawing creates a mechanical series of copies, in which the one-off motif perpetually passes through the copies of itself—or precisely with omissions regularly repeats itself.[10]

His *Fércművek* [*Threadworks*], ca. 1979, signify another variation of the indigo drawings, in which we see a band formed from vertical hatching repeated once or twice, with the frottage of one or two threads and its copy (imprint) running throughout.

The indigo works are simultaneously conceptual works and visual discoveries, or in the words of Paul Klee, signs of visual thinking. Their point of departure was an ancient theoretical and theological ("And God created man in His own

6 Beke, László, "Recurrence and Repetition in the Visual Arts", *Repetition in Art*, Iván Horváth and András Veres, eds., Opus: Irodalomelméleti tanulmányok 5 [Literary theory essays], Budapest: Akadémiai Kiadó, 1980, pp. 168–176.

7 Erdély, "Beszélgetés Erdély Miklóssal, 1983 tavaszán". The exhibition Erdély mentions was the 4th Drawing Triennial [4 Triennale Rysunku], held at the Museum of Architecture in Wrocław, Poland, May–June 1974.

8 Written by Miklós Erdély on an indigo drawing from 1980 (now missing), published in *Prospekt 80/1. 6 Hongaarse Kunstenaars*, exh. cat., Ghent: Museum van Hegendaagse Kunst, 1980.

9 Presented at the International Drawing Triennial in Wrocław. See the catalogue *Miedzynarodowe Triennale Rysunku: Wrocław Muzeum Architektury, czerwiec-lipiec-sierpien 1978* [International Drawing Triennial: Wrocław Museum of Architecture, June–July–August 1978], Wrocław: n.p., 1978.

10 Beke, László: "The Concept of 'Drawing' in Wrocław", *Művészet Évkönyv '78* [Art almanac '78], Budapest: Corvina Kiadó, 1979, p. 276.

image") fundamental assumption in connection with visual depiction, to which Erdély responded in a unique fashion.[11] The placement of the original and the copy in the same medium, on the same surface, obviously points beyond a medium-centric or self-referential conceptualism, or concretism taken in the broadest sense. A metaphorical understanding of 'surface' or 'medium' made it possible for him to bring about a new turn in the theory of depiction, and, in a figurative sense, in the theory of creation, in the problematic field of the original and the copy that "generally... are found on separate surfaces".[12] In this context, it is important to note that Erdély conceived of the process of drawing also as an event—as an 'act of creation', or as a 'picture story' or 'graphic novel'.[13] This is manifest not only in the interplay of lines, but also in the very gesture of drawing a line, in the contact—the touch—of graphite to paper. In 1980 he said, in connection with his graphic work *Kontextus I [Context I]* (the inscription "Pista" "Stevie" on a sheet of paper)[14] and his photographed action, *Szent vonal [Sacred Line]*:[15]

> What a spiritual moment it is when one places the graphite pencil on the clean, white sheet, or does anything

at all. For instance, if I write: 'Pista'.... Afterwards, I thought about how I could render this more ethereal. And then I came upon the 'sacred line' issue: I place lead on a pencil, I tie a string to its end, and I draw the line like this. And really, this is an absolute moment of leaving a trace, such a noble compromise of an intervention and the independent behaviour of the material, that perhaps somewhere in the divine realm there might be such a thing. To slightly leave the material to itself, so that it does what it wants, yet to guide it. Sometimes I have the feeling that with such a method, it is not possible to draw an ugly line.[16]

In this sense, the indigo drawings are 'ethereally beautiful': abstract works of lines, bundles of lines, twisted lines, inflected lines, hatchings, and other 'line-creations' about the abstracted correlations between the original and the copy, whose conceptual beauty and beauty of the concept—are one and the same.[17]

Translated by Adele Eisenstein

11 Erdély's 1974 work *Creation-History (Pencils Drawing Each Other)*, held by the Estate of Miklós Erdély, formulates the question of the original and the copy as the dialectic of the creator and the created; it also touches on the theological foundations of Western pictorial theory. In a typed text (held by the Erdély Estate), we find: "A non-existent pencil, while drawing another pencil, also draws itself. All paths are the contours of a pencil", while the inscriptions on the work itself are: "The Creator comes into being through creation", "The Creator becomes exactly the same as the created (Swedenborg [1688–1772]: 'The Universe is Human-Formed')", "And God created man in His own image."

12 Erdély's text from *Prospekt 80/1*, see n. 8.

13 In connection with this, see the work mentioned in note 11, which was exhibited in the Young Artists' Club (FMK) in 1975, at a show entitled *Képregény [Comic Strip]*.

14 Held by the Estate of Miklós Erdély; first exhibited in the show *Rajz / Drawing*, Municipal Gallery, Pécs, 9–31 March 1980.

15 The photographs are by György Erdély and Dóra Maurer. Estate of Miklós Erdély. The work was first exhibited in the show *Vonal / Line / Linie / Ligne,* Municipal Gallery, Pécs, 26 April–17 May 1981. It was most recently exhibited in the shows *Erdély Miklós és az Indigo. Fotókiállítás [Miklós Erdély and Indigo: Photo Exhibition]*, in collaboration with the Miklós Erdély Foundation, Kisterem, Budapest, 15 May–13 June 2008; *Miklós Erdély und die Indigo Gruppe. Fotoarbeiten aus den 70er und 80er Jahren*, in collaboration with Kisterem Budapest and the Miklós Erdély Foundation, Georg Kargl Box, Vienna, 1 July–23 August 2008; and *Pont, vonal mozgásban / Point, Line in Movement*, exhibition of the Nyílt Struktúrák Művészeti Egyesület / Open Structures Art Society, curated by Dóra Maurer, Judit Nemes, and István Haász, Vasarely Museum, Budapest, 14 October 2010–6 January 2011.

16 Erdély, "Új misztika felé", pp. 373–374.

17 For more on the subject, see: Erdély, Miklós, and László Beke, "Egyenrangú interjú" ["Interview of equal peers"], *Hasbeszélô a gondolában: a tartóshullám antológiája* ["Ventriloquist in the gondola: The permanent wave anthology"], László Beke, Dániel Csanády, and Annamária Szőke eds., Budapest: ELTE Bölcsészettudományi Kar, 1987, p. 181; and Andrási, Gábor, "A gondolat formái" ["Forms of thinking"], *Nappali Ház,* no. 2, 1993, pp. 70–71, 74–75.

Miklós Erdély

Theses on the Theory of Repetition

1. The unique is devaluated by repetition, which increases its concrete and diminishes its essential existence.
2. Only what is repeated is manifested; only what is repeated is non-existent.
3. The non-existent is sensed by referring to memory.
4. What is born, created or changing, is manifested in repetition; it also dies in repetition.
5. In the turmoil of creation the same can never be achieved twice.
6. Creation accumulates imperceptibly, and manifests itself suddenly.
7. The absolutely new is unrecognisable, unperceivable, and thus it cannot manifest itself.
8. In the process of representation the thing represented suffers substantial mutilation. This constitutes the fallacy of traditional art, which originally formed the means of the magical engagement with the forces of evil and destruction. The representation is partial, since the represented is not reproduced in its own material; thus equally partial is the elimination of the represented. This constitutes the limitation of the magical representation.
9. The perfect copy of the accidental reduces the feeling of the accidental.
10. The existence of human duplicates, twins, is a depressing absurdity and a metaphysical scandal for the individual consciousness, because it increases the feeling of the accidental.*
11. The psychic duplicate (déjà-vu) enhances self-awareness by emphasising the uniqueness of the Self in complete repetition.
12. By moulding matter, which otherwise would be formed accidentally or according to its own structural properties, into identical forms, serial production protects the consciousness from a feeling of alienation with respect to the natural environment, at the same time ushering it toward the general through the avoidance of the 'common'.
13. Since people can stand neither the catalepsy of total identification nor the vertigo of continuous change and diversity, they regard the sphere of resemblances and analogies, rhythmical changes and dialectical periods as their own. They look for the same in the different, and the different in the identical. The man of intellect, however, can only recognise himself in total change.

* In the words of Miss XY, "I do not represent my twin sister."

Translated by Zsuzsa Gábor and John Batki

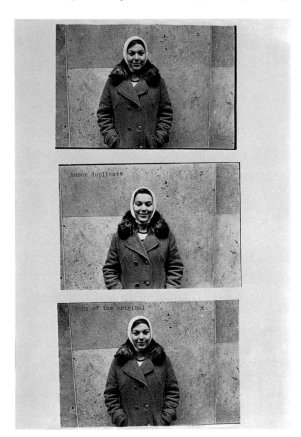 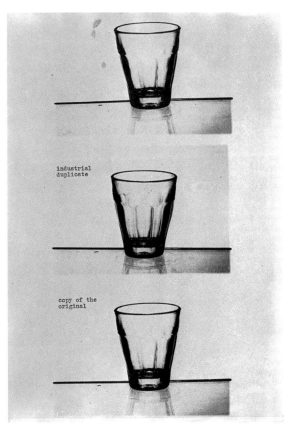

Illustrations to Theses on the Theory of Repetition and Studies in the Theory of Identification, 1972–1973:

Human Duplicate (left)
Forte Dokubrom photographic copy paper, silver gelatin print
29.5 x 21 cm
Typewritten inscriptions: "human duplicate", "copy of the original"
Estate of Miklós Erdély (EM Kat. Fom 32-1a-1)

Industrial Duplicate (right)
Forte Dokubrom photographic copy paper, silver gelatin print
29.5 x 21 cm
Typewritten inscriptions: "industrial duplicate", "copy of the original"
Estate of Miklós Erdély (EM Kat. Fom 32-4a-1)

Miklós Erdély

Studies in the Theory of Identification

1. When I see a duplicate, I might think that I see the same.
2. When I see the same, I might think that I see a duplicate.
3. When I see the same thing after it has been changed, I do not know that I see the same.
4. When I see something else, I might think that I see the same after it has been changed.
5. When something has been changed, I can still think that I see the same, even if it has been changed completely.
6. When I see something which looks absolutely identical to something that I already saw, I can still think that I am seeing something else.
7. The only time I cannot think that I see something else is when I am seeing the same thing continuously.
8. When I see something continuously, then what I see is the separate story proper to this thing.
9. When the story of something is interrupted and then continues later, I might think that the thing itself has terminated and the story of something else has begun.
10. The identity of a thing to itself is determined by the continuity of its story, or to put it more simply, its fate.

Translated by Zsuzsa Gábor and John Batki

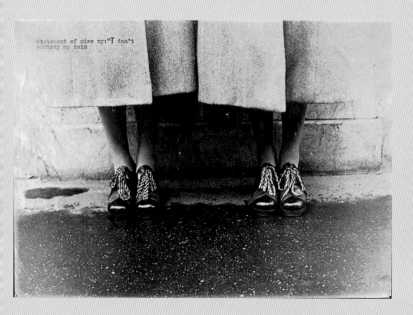

Illustrations to Theses on the Theory of Repetition and Studies in the Theory of Identification, 1972–1973:

Statement of Miss XY (opposite)
Forte Dokubrom photographic copy paper, silver gelatin print
29.5 x 21 cm
Typewritten inscription: "statement of miss xy: "i don't portray
my twin". The letter 'i' has been corrected as 'I'.
Estate of Miklós Erdély (EM Kat. Fom 32-8)

Typographical Duplicate (above)
Forte Dokubrom photographic copy paper, silver gelatin print
29.5 x 21 cm
Private collection (EM Kat. Fom 32-3)

Acknowledgements

The organisers of the 30th Biennial of Graphic Arts gratefully acknowledge the contributions of the following organisations, groups, and individuals:

Akademija likovnih umjetnosti Sarajevo
Akademija za likovno umetnost
in oblikovanje, Ljubljana
Aksioma—Institute for
Contemporary Arts, Ljubljana
Ayyam Gallery, Dubai
The Biennial of Moving Image/
Contour Mechelen, Belgium
The Liverpool Biennial—The UK Biennial
of Contemporary Art, United Kingdom
Center in Galerija P74, Ljubljana
Centar za grafiku i vizuelna istraživanja,
Fakultet likovnih umetnosti u Beogradu
Chantal Crousel Gallery
Contemporaneo, Buenos Aires
Contour Mechelen, Belgium
Društvo likovnih umetnikov Ljubljana
Ex-garage, Maribor
Miklós Erdély Foundation (EMA)
Fundació Pilar i Joan Miró a Mallorca
Galeria Pedro Cera, Lisbon
Galerija Cankarjevega doma
(Cankarjev dom, Kulturni in
kongresni center), Ljubljana
Galerie Duplex-10m2 Sarajevo
Galerie Nordenhake, Berlin/Stockholm
Galerija Equrna, Ljubljana
Galerija Grafički Kolektiv, Beograd
Galerija Jakopič, Muzej in galerije
mesta Ljubljane (MGML)
Galerija Kapelica, Ljubljana
Galerija Kresija, Ljubljana
Galerija Lek, Ljubljana
Galerija likovnih umjetnosti, Osijek
Galerija Nova, Zagreb
Galerija Škuc, Info Škuc, Ljubljana
GIBCA—The Göteborg International
Biennial for Contemporary Art (Sweden)
Gladstone Gallery
Alexander Gray Associates, New York
Greta, Zagreb
Guest Room Maribor
Ingráfica/Asociación Hablar en

Arte/Javier Martín-Jiménez
Institut d'Estudis Baleárics
Kulturni center Tobačna 001, Ljubljana
Kulturni inkubator, Maribor
Kulturno izobraževalno
društvo Kibla, Maribor
Ignacio Liprandi Arte
Lisson Gallery
Ljubljanski grad (Ljubljana Castle)
Moderna galerija in Muzej
sodobne umetnosti Metelkova,
Ljubljana (MG+MSUM)
Muzej in galerije mesta Ljubljane (MGML)
Muzej savremene umetnosti
Beograd (MSUB)
Muzej suvremene umjetnosti
Zagreb (MSU)
LeRoy Neiman Center for Print
Studies, Columbia University
Pace Gallery, New York
Pekarna magdalenske mreže, Maribor
Prometeogallery di Ida
Pisani, Milan/Lucca
Calcografía Nacional, Real Academia de
Bellas Artes de San Fernando, Madrid
Remont—nezavisna umetnička
asocijacija, Beograd
Radio televizija Slovenija
Slobodna umetnička
zadruga Treći Beograd
Slovenska turistična organizacija
Turizem Ljubljana
Umetnostna galerija Maribor
WHW—što, kako i za koga, Zagreb

Zdenka Badovinac
Aleksander Bassin
Ajdin Bašić
Petra Bizilj
Tomaž Brejc
Josip Butković
Luis Camnitzer
Branko Franceschi
Pierre Courtin
Jacob Fabricius
Maja Finžgar
Bojan Gorenec
Alenka Gregorič

Ivana Janković
Meta Kordiš
Arven Šakti Kralj Szomi
Yongwoo Lee
Tevž Logar
Martina Merslavič
Suzana Mihalič
Edi Muka
Primož Nemec
Steven Op de Beeck
Marko Ornik
Jan Oršič
Sergej Pavlin
Blaž Peršin
Mateja Podlesnik
Tadej Pogačar
Arjan Pregl
Iztok Premrov
Tatjana Radovič
Bojana Rogina
Mitja Rotovnik
Barbara Savenc
Gemma María Santiago Alonso
Marija Skočir
Zoran Srdić
Petra Stušek
Boža Šuljgič
Polona Štebe
Sally Tallant
Etienne Van den Bergh
Vladimir Vidmar
Borut Wenzel
Mojca Zlokarnik

The 30th Biennial of Graphic Arts Ljubljana is supported by

 REPUBLIKA SLOVENIJA
MINISTRY OF CULTURE

 Mestna občina
Ljubljana

Main sponsor

 lek

a Sandoz company

Sponsors

 AdriaticSlovenica

 MARAND
Napredna računalniška hiša

8**55** RTV SLO | Televizija Slovenija

 RADIO ŠTUDENT FM89.3

 MEDIA BUS
MEDIJ V GIBANJU

Supported also by

 U.S. Embassy
Ljubljana

 EMBAJADA DE ESPAÑA EN ESLOVENIA

 EMBAIXADA DO BRASIL EM LJUBLJANA
VELEPOSLANIŠTVO BRAZILIJE V LJUBLJANI

 TURKISH EMBASSY LJUBLJANA

 EMBASSY OF HUNGARY IN LJUBLJANA

 Ljubljana
Ljubljana Tourism

 Culture

Organisation of the 30th Biennial of Graphic Arts Ljubljana

ORGANISER
The International Centre of Graphic Arts

**THE BOARD OF THE INTERNATIONAL
CENTRE OF GRAPHIC ARTS**
Elizabeta Petruša Štrukelj
(president), Sašo Urukalo, Anton
Kastelic, Tanja Dornik
Poglič, Božidar Zrinski

CO-ORGANISERS
Cankarjev dom—Culture and
Congress Centre, Moderna
galerija (The Museum of
Modern Art), The Museum
and Galleries of Ljubljana

AWARD JURY
Chema de Francisco, Sally Tallant,
Dusica Kirjakovic, Tevž Logar

**PARTICIPATING GALLERIES
AND EXHIBITION SITES**
The Cankarjev dom Gallery, The
Jakopič Gallery (The Museum and
Galleries of Ljubljana), Moderna
galerija (Museum of Modern Art) and
the Museum of Contemporary Art
Metelkova, Jakopič Promenade, Švicarija
Building, Pentagonal Tower (Ljubljana
Castle), Kresija Gallery, Lek Gallery,
Calcografía Nacional, Real Academia
de Bellas Artes de San Fernando,
Madrid, Hablar en arte Madrid

CURATOR
Deborah Cullen

DIRECTOR
Nevenka Šivavec

ASSISTANT DIRECTOR
Yasmín Martín Vodopivec

COORDINATOR
Božidar Zrinski

ASSISTANT COORDINATOR
Boris Beja

**EDUCATIONAL AND ACCOMPANYING
PROGRAMMES**
Lili Šturm

PUBLIC RELATIONS
Karla Železnik, Darja Demšar

MARKETING
Petra Klučar

GRAPHIC DESIGN
Ivian Kan Mujezinović

**LOGISTICAL AND TECHNICAL
ORGANISATION**
Alenka Močnik, Slavko
Pavlin, Bogdan Knavs

ACCOMPANYING EXHIBITIONS

*The Biennial of Graphic Arts—
Serving You Since 1955*, curated
by Petja Grafenauer

Exhibition of the Grand Prize Winner
of the 29th Biennial of Graphic Arts:
*Regina José Galindo: The
Anatomy Lesson*, curated by
Yasmín Martín Vodopivec

Exhibition of the Honourable
Mention Recipient of the 29th
Biennial of Graphic Arts:
*Miklós Erdély: The Original and
the Copy + Indigo Drawings*,
curated by Annamária Szőke

Fundació Pilar i Joan Miró a Mallorca:
Joan Miró's Printmaking Workshops,
curated by Elvira Cámara López

*Robert Morris from the MGLC
Collection*, curated by Breda Škrjanec

Calcografía Nacional, Real
Academia de Bellas Artes de San
Fernando, Madrid: *Impressions
+386*, curated by Breda Škrjanec

Leisure, Discipline and Punishment,
project supported by the European
Commission, coordinated by Lela B.
Njatin, Nevenka Šivavec, Lili Šturm

*A Tribute to the Biennial: Prints
from the MGLC Collection*,
curated by Iztok Premrov

What happened, Student
Exhibition of Ljubljana Academy
of Fine Arts and Design

The 30th Biennial of Graphic Arts Ljubljana

PUBLISHED BY
Black Dog Publishing, London, UK
10A Acton Street
London
WC1X 9NG
UK
www.blackdogonline.com
T: + 44 (0) 207 713 5097,
F: + 44 (0) 207 713 8682

and

The International Centre of Graphic Arts
Grad Tivoli, Pod turnom 3
SI-1000 Ljubljana
Slovenia
www.mglc-lj.si
T: +386 (0) 1 2413 800,
F: +386 (0) 1 2413 821

Represented by
Nevenka Šivavec

EDITOR
Deborah Cullen

EDITORIAL COORDINATOR
Darja Demšar

AUTHORS
Nevenka Šivavec, Petja Grafenauer,
Deborah Cullen, Yasmín Martín
Vodopivec, Annamária Szőke; artwork
notes written by Deborah Cullen
based on the artists' statements

SLOVENE-TO-ENGLISH TRANSLATION
Rawley Grau

SPANISH-TO-ENGLISH TRANSLATION
Odile Cisneros

HUNGARIAN-TO-ENGLISH TRANSLATION
Adele Eisenstein, Zsuzsa
Gábor, John Batki

ENGLISH LANGUAGE EDITOR
Rawley Grau

CATALOGUE DESIGN
Ivian Kan Mujezinović

PRINTED IN THE EU

This book is published in
conjunction with the exhibition
*Interruption: The 30th
Biennial of Graphic Arts*,
Ljubljana, Slovenia,
14 September—24 November 2013.
http://www.mglc-lj.si/eng/the_biennial

All artwork images © the artists
and photographers as noted.
© 2013, BLACK DOG PUBLISHING
ISBN13: 978 1 908966 30 8

© 2013, THE INTERNATIONAL CENTRE
OF GRAPHIC ARTS (MGLC)

art design fashion
history photography
theory and things

www.blackdogonline.com